Francis Bacon

Past Masters

AQUINAS Anthony Kenny
FRANCIS BACON Anthony
 Quinton
BURKE C. B. Macpherson
DANTE George Holmes
GALILEO Stillman Drake

HOMER Jasper Griffin
HUME A. J. Ayer
JESUS Humphrey Carpenter
MARX Peter Singer
PASCAL Alban Krailsheimer

Forthcoming

ARISTOTLE Jonathan Barnes
AUGUSTINE Henry Chadwick
BACH Denis Arnold
BAYLE Elisabeth Labrousse
BERGSON Leszek Kolakowski
BERKELEY J. O. Urmson
CARLYLE A. L. Le Quesne
COBBETT Raymond Williams
CONFUCIUS Raymond Dawson
COPERNICUS Owen
 Gingerich
DARWIN Jonathan Howard
DIDEROT Peter France
ENGELS Terrell Carver
ERASMUS James McConica
GIBBON John Burrow
GODWIN Alan Ryan
GOETHE J. P. Stern
HEGEL Peter Singer
HERZEN Aileen Kelly
JEFFERSON Jack P. Greene
LAMARCK L. J. Jordanova

LINNAEUS W. T. Stearn
LOCKE John Dunn
MACHIAVELLI Quentin
 Skinner
MALTHUS Gertrude
 Himmelfarb
MILL William Thomas
MONTAIGNE Peter Burke
THOMAS MORE Anthony
 Kenny
MORRIS Peter Stansky
NEWMAN Owen Chadwick
NEWTON P. M. Rattansi
PLATO R. M. Hare
ROUSSEAU John McManners
ST PAUL Tom Mills
SHAKESPEARE Germaine
 Greer
ADAM SMITH A. W. Coats
TOLSTOY Henry Gifford

and others

Anthony Quinton

FRANCIS BACON

Oxford Toronto Melbourne

OXFORD UNIVERSITY PRESS

1980

This book is dedicated with admiration and gratitude to
Tadeusz Kotarbiński, whose own book on Bacon was
destroyed in and with the city of Warsaw by one of the
forms of totalitarian evil which have afflicted his country
and which he has always magnificently opposed.

Oxford University Press, Walton Street, Oxford OX2 6DP

London Glasgow New York Toronto
Delhi Bombay Calcutta Madras Karachi
Kuala Lumpur Singapore Hong Kong Tokyo
Nairobi Dar es Salaam Cape Town
Melbourne Wellington

and associate companies in
Beirut Berlin Ibadan Mexico City

First published as an Oxford University Press paperback
1980 and simultaneously in a hardback edition

British Library Cataloguing in Publication Data

Quinton, Anthony Meredith
Francis Bacon. – (Past Masters)
1. Bacon, Francis, Viscount St Albans
I. Series
192 B1198
ISBN 0-19-287525-6
ISBN 0-19-287524-8 Pbk

Printed in Great Britain by
Cox & Wyman Ltd, Reading

Contents

Abbreviations

References in the text to Bacon's writings are given by an abbreviation of the title of the work in question, followed by a page-reference to *The Philosophical Works of Francis Bacon*, reprinted from the edition of Ellis and Spedding and edited by John M. Robertson, London, 1905.

The abbreviations are as follows:

A The Advancement of Learning

G The Great Instauration

D De Augmentis (= De Dignitate et Augmentis Scientiarum)

E Essays

N Novum Organum

S New Atlantis

L Life, by Dr W. Rawley

For A and N references are first given to books and then, in A, to chapter and section, and in N to aphorism; the Ellis and Spedding page-reference follows after a full point.

1 Life

Francis Bacon was born on 22 January 1561 at York House, off the Strand in London. He was the second son of Sir Nicholas Bacon, Lord Keeper, and of his second wife, Ann Cooke. Nicholas Bacon had been born in 1509 in a comparatively modest social position: his father, according to the *Dictionary of National Biography*, being 'sheepreeve to the abbey of Bury St Edmunds'. But he got to Cambridge, became friends there with William Cecil, later Lord Burghley and Elizabeth's chief minister, and with Matthew Parker, later archbishop of Canterbury. In the 1540s he acquired a good deal of former monastic land and with the accession of Elizabeth was appointed Lord Keeper. Even if this was through the good offices of Cecil, Nicholas Bacon soon showed his capacity for a high post. Unlike his famous son, he was 'exceeding gross-bodied'.

Bacon's mother was a well-educated and doctrinally rigid Calvinist. It is possible to interpret her son's piously expressed insistence on the size of the gap that separates knowledge of nature, based on sense and reason, from supernatural knowledge, based on revelation, as a direct consequence of her severely Protestant teaching, on the assumption that the pious professions are sincere, or as an ironic rejection of that teaching, if they are not. Anne Bacon was the sister of the wife of William Cecil, her husband's Cambridge friend, the Lord Burghley who was to be the largely unresponsive object of constant pleas for preferment from her son, Francis.

Bacon accompanied his elder brother, Anthony, to Trinity College, Cambridge, in April 1573 at the seemingly rather unripe age of twelve years and three months. They stayed there for only two years. It has been speculated that Bacon must have been influenced by the philosophical currents running there at the time. In particular it has been suggested that he may have attended lectures at which the new logic of Ramus was expounded. Everard Digby, who was to defend the old logic

against the Ramism of his former pupil, William Temple, in the 1580s, became a fellow of St John's and began to lecture on logic in the year Bacon arrived in Cambridge. Much later in life Bacon said to his biographer, Rawley, that at Cambridge, 'he fell into the dislike of the philosophy of Aristotle; not for the worthlessness of the author, to whom he would ever ascribe all high attributes, but for the unfruitfulness of the way' (L2).

It is easy to understand why Bacon's biographers should seize on any possible clue to the development of his mind. From the time he left Cambridge when still less than sixteen until his disgrace in 1621 at the age of sixty he was continuously engaged in a busy public career: legal from the date of his father's death in 1579, frequently political or in the direct service of the crown. Where in all this and the extravagant glorification of his estate at Gorhambury was there time to acquire the stores of knowledge which made his gigantic philosophico-scientific project at least not ridiculously overweening, and enabled some substantial chunks of it to be realised?

The year after he left Cambridge Bacon accompanied Sir Amias Paulet on his embassy to France. He was still out of England in February 1579 when his father died. Bacon found himself in unexpectedly pinched circumstances and enrolled at Gray's Inn as a first step towards the repair of his fortunes. In 1582 he became a barrister, and two years later entered the House of Commons as member for Melcombe Regis, the first of a large number of places he was to represent. Before he was twenty he had begun the long-drawn-out process of badgering for favour, starting with his uncle Burghley, but going on in due course to other, sometimes more forthcoming patrons, such as Essex, Queen Elizabeth, Buckingham and King James I. It is naturally conjectured that Burghley's generally unenthusiastic response to his gifted nephew's solicitations was due to concern for the worldly fortunes of his own, rather less gifted, son Robert Cecil, later Earl of Salisbury, who despite his second-rate, if sturdy, abilities, succeeded his father as chief minister and remained in that position until his death in 1612.

Some time in 1591 Bacon made the friendship of the Earl of Essex, Elizabeth's last favourite, still in some disgrace for his

marriage, not approved by the queen, to the widow of Sir Philip Sidney. Only twenty-three, Essex was six years younger than Bacon. His highest moment as a national hero after the expedition to Cadiz was still three years ahead. In 1592 Bacon wrote in a letter to Burghley the famous sentence, 'I have taken all knowledge for my province.' Perhaps the main outlines of 'The Great Instauration', the fabulous, grandiose programme of Bacon's intellectual career, were already worked out by this time. He was more visibly active in the world of public affairs. Essex's favour, often self-destructively impetuous, failed to secure for Bacon the post of Attorney-General. It went to the man who was to be throughout his life his most persistent enemy, Edward Coke, defender of the common law against absolutist tendencies in Elizabeth and James I. Even the lesser post of Solicitor-General was not forthcoming, since Bacon had aroused the queen's resentment by parliamentary opposition to her taxation policies.

During this comparative lull in his activities Bacon may have been engaged on writing the first of his *Essays*. The first collection of them, ten in number, came out in 1597. (They reached their final total of fifty-eight in the edition of 1625, a year before Bacon's death.) His financial affairs were in a bad state. In 1598 he was briefly arrested for debt. The disastrous failure of Essex's Irish expedition gave Bacon an opportunity to retrieve his position in the eyes of the queen, and to give evidence of somewhat reptilian qualities of character. Essex was informally tried for mismanagement and disobedience to the queen's commands. Enraged and affronted by his fall from the queen's favour, Essex planned an insurrection. The support on which he had counted failed to appear and he was soon a prisoner.

Both Bacon and Coke took part in the ensuing prosecution. Coke performed in a muddled and incompetent fashion and Bacon had to rescue the proceedings from his clumsiness. Essex was condemned and executed. Bacon has been much blamed for his betrayal of Essex, but, whatever responsibility he may bear for encouraging Essex to pursue his Irish misadventure, he does not seem to have had any knowledge of Essex's plot to

seize the position of chief minister by a violent *coup d'état*.

These at least somewhat morally ambiguous services to the crown do not appear to have done anything to overcome Elizabeth's dislike for or distrust of Bacon. With her death in 1603 and the accession of James I Bacon's hopes of preferment once more came to life. He was indeed knighted four months after the the new king came to the throne, but the lustre of that honour was dimmed by the fact that it was also conferred on three hundred other people. He was active in Parliament, particularly in working on the consequences of the union of the English and Scottish crowns, but there was no preferment until in 1607 he finally achieved the Solicitor-Generalship, Coke being no longer an obstacle since his promotion to the bench in the previous year.

In 1606 Bacon married Alice Barnham, daughter of a sheriff of London and an heiress. The *Encyclopaedia Britannica* says that 'it seems that [this] marriage ... though childless, was not unhappy'. Aubrey takes a more colourful view of Bacon's domestic life, saying that he was a pederast and that 'his Ganimeds and favourites tooke bribes; but his lordship always gave judgement *secundum aequum et bonum*'. He goes on to suggest that Bacon's wife was not without consolation. 'His dowager', he writes, 'maried her gentleman-usher Sir (Thomas, I thinke) Underhill, whom she made deafe and blind with too much of Venus.'

In 1605 the first of Bacon's philosophical writings was published: *The Advancement of Learning*. The first book is a flowery panegyric to learning; the second, more than twice as long, is largely taken up with a highly elaborate classification of the varieties of knowledge that has exercised a profound influence on the arrangement of libraries and of encyclopedias ever since. Four years later Bacon's *De Sapientia Veterum* came out, an interpretation of the moral and prudential meaning of ancient myths that was, after the *Essays*, the most widely read of Bacon's books in his own lifetime. In 1610 he wrote his *New Atlantis* (it was not published until after his death), in which his influential views about the social nature of scientific research were put forward in imaginative form.

The welcome death of the hated Salisbury in 1612 brought Bacon back to the public world. The other main human obstacle to his political advancement, Coke, was removed, not by death, but by promotion to the court of King's Bench at Bacon's suggestion. Now at last he achieved the post of Attorney-General he had pursued for such a long time. He addressed himself effectively to the king's new favourite, George Villiers, soon Earl, and eventually Duke, of Buckingham. He occupied himself with supporting the royal prerogative against the ancient rights and customs defended so doggedly by Coke, and developed his far-seeing ideas about the rationalisation of law.

In 1615 the case of Peacham took the long-standing hostility between Bacon and Coke a stage further and also supplied more material for assaults by Macaulay on Bacon's character. Peacham was a clergyman suspected of seditious conspiracy on account of notes for a sermon found among his papers. He was tortured, in Bacon's presence, to reveal his presumably non-existent accomplices, without success. In going on to prosecute Peacham for treason anyway, the government, advised by Bacon, sought the judges' opinions severally and not as a group. A series of collisions between Coke and the king about the jurisdiction of various courts, and, in the end, about the king's power to draw the boundaries between them, led to James's dismissal of Coke. In 1617 Villiers secured for him his father's post of Lord Keeper and, finally, in 1618 he achieved the highest legal position under the crown, that of Lord Chancellor.

Just as his fortunes seemed assured and his odious rival, Coke, irretrievably humiliated, Bacon slipped up again in the matter of the marriage contracted between the younger brother of his patron, Villiers, and the daughter of Coke. The young woman's mother was opposed to the marriage and Bacon thought to press Coke further down by obstructing it. His interference infuriated Buckingham and also the king. He apologised cringingly and in 1618 became Lord Verulam. In 1621 he was raised to the rank of Viscount St Albans. Less than three months later the greatest of all his misfortunes broke upon

him in the form of petitions to the House of Commons charging him with bribery. The House of Lords took up the investigation, Bacon fell ill, thought of defending himself and, in the end, self-abasingly admitted the charges against him. The sentence delivered was severe: a fine of £40,000, imprisonment in the Tower during the king's pleasure, disqualification from Parliament and exclusion from the court and its neighbourhood. In fact the fine was, in effect, remitted; he remained only two or three days in the Tower. But he was unable to get released from his exclusion from within twelve miles of court until he had sold his birthplace and grand London dwelling, York House, to the greedy Buckingham, acting here with all the polished elegance of a looter scavenging at the scene of an air crash.

This reversal was the end of Bacon's public life. But he remained active and enterprising until his death five years later. *Novum Organum,* the second of his major philosophical works, had been published in 1620, a year before the catastrophe. Less than six months after sentence had been passed on him he had finished his monograph on King Henry VII. Two compilations of natural history, raw material arranged for investigation by the method he had worked out in *Novum Organum,* soon followed: *Historia Ventorum* in 1622, *Historia Vitae et Mortis* the year after. Also in 1623 he published *De Augmentis,* a considerably enlarged version of *the Advancement of Learning* of eighteen years earlier.

He did not give up his life-long habit of pestering the great for preferment. He sent a copy of *Novum Organum* to the king, who likened it, in a well-used formula, to the peace of God, since it passed all understanding. The story of his death, recounted by Aubrey, is well-known. It should be quoted in Aubrey's words.

He was taking the aire in a coach with Dr Witherborne (a Scotchman, Physitian to the King) towards High-gate, snow lay on the ground, and it came into my lord's thoughts, why flesh might not be preserved in snow, as in salt. They were resolved they would try the experiment presently. They alighted out of the coach, and went into a poore woman's howse at the bottome of Highgate hill, and bought

a hen, and made the woman exenterate it, and then stuffed the bodie with snow, and my lord did help doe it himselfe. The snow so chilled him, that he immediately fell so extremely ill, that he could not then return to his lodgings (I suppose then at Graye's Inne), but went to the earle of Arundell's house at High-gate, where they putt him into a good bed warmed with a panne, but it was a damp bed that had not been layn-in in about a yeare before, which gave him such a cold that in two or three dayes, as I remember he [Hobbes, Aubrey's informant] told me, he dyed of suffocation.

Bacon's character has not been much admired. Pope's couplet is memorably concise:

> If parts allure thee, think how Bacon shined,
> The wisest, brightest, meanest of mankind.

It was a period when the more agreeable aspects of human nature were not much encouraged in English public life. Elizabeth and James I had some excuse in the dreadful fates of their respective mothers. The Cecils were devious and insincere: James I's catamites, Somerset and Buckingham, much worse. It is Bacon's special misfortune to have been the subject of a marvellously readable but rollickingly injudicious essay by Macaulay, in which the worst construction is put on his not unrepresentative fawning on the great, his betrayal of Essex and the malpractice that brought down on him the disaster of 1621.

He seems to have been a fairly cold fish. He said of himself, 'I have rather studied books than men', and ordinary private affections appear to have played little part in his life. If so it may help to explain how he managed to achieve as much as he did of his grand design while caught up, in Macaulay's phrase, with 'so much glory, so much shame'.

2 The intellectual background

In the history of English philosophy as it has usually been presented, Bacon stands out sharply, as a systematic thinker on a large scale, emerging in a wholly unanticipated way after a period of unrelieved stagnation. Careful reading of the small print of intellectual history often dissipates this kind of impression of absolute novelty. Bacon's case is not exceptional. All the same there is no doubt that the completed part of his giant project does add up to a system, even if the proportion of rhetoric to reasoning is much higher than in the work of his near-contemporary, Descartes, who is still to this day something of a model of philosophical professionality. It is also true that, even though much of what Bacon has to say can be traced in previous writers, these were, with one very important exception, not English. Rather like Bertrand Russell, Bacon served to bring to notice in this country tendencies on the other side of the Channel hitherto only dimly perceived.

The last great century of English (or British) philosophy had been the fourteenth. During its first half, ending with the Black Death, the most vigorous philosophical movement in Christendom was the group of Franciscan thinkers in Oxford whose most prominent members were Duns Scotus and William of Ockham. Very briefly put, their common, negative, achievement was to undermine the remarkable synthesis of Christian doctrine and the philosophy of Aristotle which had been constructed by Thomas Aquinas. He had tried with the greatest learning and ingenuity to provide rational arguments, Aristotelian in form and often in their foundations, for nearly all the main Christian dogmas (he had to admit that the doctrine of the Trinity depended on revelation).

Duns Scotus stood to Aquinas rather as Kierkegaard to Hegel, that is to say as one concerned to re-complicate what another had oversimplified. Ockham agreed that the human reason could achieve little in the supernatural domain of

theology, but, on the positive side, went beyond Duns Scotus into a theory of natural knowledge as derived from the senses which was the first major presentation of the empiricism that has subsequently been the dominant British philosophy. It is Ockham, in particular, who is the exception to the principle that Bacon's main sources are not English. For in his development of the brief and nebulous account of induction given by Aristotle in various places in the logical writings that make up his *Organon* he explicitly sets out the main principles of the eliminative method that were systematised in Bacon's 'tables'.

Ockham himself died of the Black Death. His ideas were kept very much alive, but for the most part in France. To an increasing extent, furthermore, the school of Ockham became concentrated on physics. The scientific movement of the late fourteenth century was centred in Paris; its chief exponents, John Buridan, who anticipated the principle of inertia crucial to Galilean physics, and Nicholas of Oresme, who held, a century and a half before Copernicus, that the hypothesis of the earth's motion was, at any rate, consistent with the observed facts, were both French.

In his own country Ockham was succeeded by some able logicians but the fate of philosophy is represented, as it was (at least in part) caused, by the career of John Wycliffe. Wycliffe began as a traditionally-minded systematic philosopher. Subversive ideas about authority in Church and State supplanted his more abstract interests and brought him into disfavour. It was appropriate that he should work for a vernacular Bible, holding the prematurely Protestant ideas he did. The fierce suppression of his followers, the Lollards, after his death and into the next century, seems to have extinguished original thought in Oxford. The first signs of new life there were only marginally philosophical, the rise of a mild and respectably unpagan version of Italian humanism, imported in the first instance by such aristocratic patrons as Humphrey, Duke of Gloucester, and John Tiptoft, Earl of Worcester, coming to full flower with the circle round Erasmus: Colet, Grocyn and, most notably, Thomas More, a hundred years after Wycliffe's

death. The intervening period in the intellectual life of the country remains obscure, most probably because there really was very little going on.

The sixteenth century was a dangerous one for theorists. Henry VIII's Reformation was a matter of Church government, not doctrine, but ideological Protestantism triumphed in the short reign of Edward VI. In the reaction under Mary the more zealous and obtrusive Protestant publicists were killed off. Finally in the reign of Elizabeth a moderate Church settlement was arrived at, and the chief thinker of the age, Richard Hooker, elaborated the theory of that settlement in a traditional, reasonable, eclectic spirit. The natural law content of his doctrine was as close to the scholastic rationalism of Aquinas as were his methods of argument. Anxious to repel the puritan conviction that divinely authoritative prescriptions for every detail of the conduct of life were to be found in scripture, Hooker reverted to the position that God's purposes for man are accessible to human reason without a particular revelation.

In thus rejecting the fideism, or theological irrationalism, of Scotus and Ockham (neither of whom was irrationalistic about *natural* knowledge), Hooker differed from most British thinkers until John Locke and the Cambridge Platonists in the second half of the seventeenth century, who agreed, in their distinct and often opposed ways, on the reasonableness of Christianity. The view that reason is limited to the natural world and incompetent to investigate God and the immortal soul can be shared by people of very different attitudes. It can be a stratagem of the devout for the protection of a faith they hold on authority. It can equally be a device for the preservation of natural inquiry from theological interference. Bacon firmly embraced it, according to most interpreters of his works, for the sake of disencumbering natural science. Some bold or hopeful commentators have claimed that his faith, firmly marked off from the sphere of rational knowledge, was sincere. Whether that is correct or not, there can be no doubt of his sincere concern for the autonomy of science.

There is a slightly suspicious resemblance between the views of Bacon about its being positively desirable that the

dogmas of religion should be hard to accept, and a famous remark of Hobbes's: 'it is with the mysteries of our religion as with wholesome pills for the sick; which swallowed whole, have the virtue to cure; but chewed up, are for the most part cast up again without effect'. Bacon expresses himself a little more piously:

The prerogative of God extendeth as well to the reason as to the will of man; so that as we are to obey the law, though we find a reluctation in our will, so we are to believe his word, though we find a reluctation in our reason. For if we believe only that which is agreeable to our sense, we give consent to the matter, and not to the author; which is no more than we would do towards a suspected and discredited witness; but that faith which was accounted to Abraham for righteousness was of such a point as whereat Sarah laughed, who therein was an image of natural reason. (A II xxv 1, 167–8)

But there are those who take even Hobbes to be a believing Christian.

The less cursory histories of English philosophy do manage to find a little activity in the mid-Elizabethan period in which Bacon grew up. They all depend on a pioneering study of 1892 by a German scholar, J. Freudenthal, who exhumed a violent controversy at Cambridge in the 1580s between Everard Digby, a conservative thinker in essentials who was nevertheless attracted towards the esoteric and mystical aspects of the revived neo-Platonism of Renaissance Italy, and William Temple, an enthusiast for the logical heresies of Ramus. For his Master of Arts degree Ramus had defended the thesis that everything affirmed by Aristotle is false. His considered view was less extreme, namely that the logic of Aristotle is artificial and intolerably and unnecessarily complicated. Logic should seek to follow the natural movement of thought, not to contort the intellect into the mechanical evolutions of the parade-ground. Thought at its best and most natural is to be found in the writings of the best, classical, authors, the proper object of humanistic study. In practice and in detail he departs surprisingly little from Aristotle, a testimony to the strength of that philosopher's grip on the European mind.

A convenient point of view for surveying the influences on

Bacon and the intellectual atmosphere of his time from continental Europe is provided by his own threefold classification of unsatisfactory styles of learning which it is his ambition to replace, set out in the first book of *The Advancement of Learning*. The first of these is *contentious* or disputatious learning, in other words scholasticism, the orthodox Aristotelian tradition. This was still, and was to remain until the end of the century, the staple mode of thought in the English universities. Hobbes and Locke were to follow Bacon in attacking its vacant, repetitious, jargon-ridden character, but not until Locke's *Essay on Human Understanding* (published in 1689) had been available for some time were the writings of Aristotle and of his train of laborious commentators to any significant extent displaced. Bacon's only institutional acknowledgement was to be by the Royal Society through the encomiums of Robert Boyle and the Society's historian Bishop Thomas Sprat.

Bacon did not have to look abroad for exponents of the contentious learning of Aristotelian scholasticism. But its English representatives in the late sixteenth century were relatively humble authors of student texts. In Catholic Europe the Council of Trent in 1545 and the support of the Jesuits, founded shortly before, led to a scholastic revival in which Aquinas himself became the main authority. The most important of these counter-Reformation scholastics was the Spaniard Francesco Suarez. His *Disputationes Metaphysicae* of 1597 was highly learned, thorough and systematic. Luther's colleague Melanchthon preserved Aristotle in the learned world of German Protestantism, even if he was hostile to the traditional scholastic elaborations of Aristotle's ideas. In Italy too, the main source of new currents of thought, Aristotle had able disciples, notably Pietro Pomponazzi, but here too he was treated in a non-scholastic, naturalistic way, and therefore not one that Bacon would have seen as disputatious.

The second of Bacon's 'vanities of learning' is the *delicate* learning, the form of intellectual life of the humanistic scholars. They, too, opposed scholasticism, but rather for its barbarous, un-Ciceronian Latin than for its abstract and empty

verbalism. Humanism as a general movement is far more than the kind of gentlemanly dilettantism and preoccupation with style rather than substance, decoration rather than content, that Bacon attacked. But the leading humanists – Erasmus, for example – were not interested in knowledge of nature, either for its own sake or, in Bacon's way, for the sake of power and the 'relief of man's estate'. At most it concerned them as an object of beauty, a setting for the free and comprehensive development of human powers which they saw as the great achievement of the ancient world and as obliterated by the gloom and self-denial of the Middle Ages.

Lorenzo Valla (1407–57) is perhaps a more representative figure than Erasmus or Petrarch, the greatest of humanist poets. He categorically asserted that pleasure is the sole end of man and attacked monasticism. A passionate enthusiast for the classical languages, he showed what expertise in them can achieve by his incontrovertible proof that the donation of Constantine, which purported to be an edict of that emperor according supreme power in the Church to the bishops of Rome, was a forgery. The classical emphasis of European education at its higher levels since the Renaissance is one consequence of humanism. Another, less obvious one is the distinction between the sciences and the humanities, the idea that a special method of inquiry must be applied to human beings and their achievements as distinct from the rest of the world. Humanistic scholarship is a matter of the interpretation of texts. In our own age it has been held by many that it is their possession of language, that of which texts are made, that makes human beings unamenable to the methods of the natural sciences. On this issue Bacon's position was clear. He praised Machiavelli, the unillusioned Florentine political theorist, for discussing men as they are rather than as they ought to be, and it is natural to suppose an affinity of sentiment between Machiavelli and Bacon. Furthermore, in his classification of the sciences Bacon put human philosophy beside natural philosophy and saw his inductive method as applicable both to man and to the rest of nature.

Bacon shared the humanists' hostility to the methods of

scholastic reasoning. He did not follow them in their indifference to its object: knowledge of the world in which man is placed. The sceptical philosophies of the Renaissance may be seen as a more or less philosophical justification of humanist unconcern with philosophy and science and their confinement to the study of human nature, the arts and polite morality. The great sceptical encyclopedia compiled by the Hellenistic philosopher, Sextus Empiricus (second or third century A.D.), became generally available from 1562, the year after Bacon's birth. Cicero's account of the sceptical teachings of the 'Academy' – as the sceptical thinkers who derived rather tenuously from Plato, founder of the original Academy, were called – were accessible to Erasmus to support his attack on scholastic dogmatism in *In Praise of Folly* (1509). Montaigne wrote his extremely influential *Apologie pour Raimond Sebond* around 1576 in reaction to the violent disturbance to his beliefs brought about by reading the newly available Sextus Empiricus. Florio's translation of Montaigne's essays appeared in English in 1603. Bacon acknowledged indebtedness to Montaigne as an essayist. But he in no way shared the general intellectual pessimism of the sceptical philosophers; his scepticism about deductive metaphysics served to make the road clear for inductive science.

Renaissance critics of Aristotle often used Plato as a stick to beat their old enemy with. That is not surprising; Aristotle is to a considerable extent engaged in criticism of Plato. But the Plato of the Renaissance philosophers is not Plato himself, but two rather different individuals, different from him and from each other. In the Florentine Academy, a circle of philosophers sponsored by the Medici that met in the last third of the fifteenth century, and named after Plato's own philosophical school, an elevated Christian neo-Platonism, affirming the beauty and harmony of the world, was developed by Marsilio Ficino and Pico della Mirandola (admired by Thomas More, who translated his biography). This form of Platonism is not interested in science; its concern is with the enjoyment of beauty and the conduct of life.

But the name of Plato was widely invoked as their inspirer by

a varied group of philosophers of nature: the German Nicholas of Cusa (1401–64), the Italians Francesco Patrizzi (1529–97), Tommaso Campanella (1568–1639) and Giordano Bruno (1548–1600). For them nature was a proper object of study in its own right. Some of them – Campanella, for example, and his teacher Bernardino Telesio (1509–88) – emphasised the role of observation with the senses. All speculated on a large scale about the form and nature of the cosmos, the physical world as a whole, terrestrial and stellar. The strongly Pythagorean, mathematical aspect of Platonism was revived by the new philosophers of nature, which in their rashly imaginative way can be seen as prefiguring the mathematically formulated systems of the cosmos of the first physicists proper: Copernicus, Kepler, Galileo.

Bacon took little account of this, more fruitful, side of naturalistic Platonism. What he did notice and identify as his third kind of defective philosophy, calling it fantastic learning, was its loosely associated underworld of believers in magic, alchemy, astrology, in the importance and availability of practical, and not simply contemplative, knowledge of nature. The most important and representative of these occult nature-philosophers was Paracelsus, whose real name was Theophrastus Bombastus von Hohenheim and who lived in the first half of the sixteenth century. Esoteric charlatanry, as well as an ultimately beneficial emphasis on experimentation, are mingled in the work of these believers in man as a microcosm of the universe, of nature as a great system of correspondences and analogies. The magical encyclopedia attributed to 'Hermes Trismegistus' (in other words the hermetic literature of the ancient world), the Jewish Cabbala and neo-Platonism were brought together in the idea of a world-spirit through which the forces of nature could be controlled for the advantage of man, as in the alchemical notions of a panacea, an elixir of life and the philosopher's stone.

Some commentators on Bacon have seen him, for all his overt hostility to the fantastic learning of the occultists, as himself ultimately one of them. This is not so much because of endorsement of what he calls 'natural magic' but because of his

neglect of the mathematical mechanics and cosmology that was the great scientific achievement of the seventeenth century, for the sake of a merely observational and experimental study of nature, undertaken for use and not for the sake of knowledge itself. This is to ignore his insistence on methodical procedure, on the social nature of scientific inquiry and on the capacity of anyone, going about it in the right way, to secure useful scientific knowledge for himself.

The most notable English occult philosopher is Robert Fludd, a younger contemporary of Bacon's, who produced a defence of the Rosicrucians in 1616 and in subsequent years a series of volumes about the universe as everywhere made of the same two materials and thus permeated by sympathies and antipathies whose perceptible signs can be interpreted by the initiated.

Three of the four major currents of thought in Bacon's time are, then, identified in his catalogue of philosophies that deserve to be rejected. Aristotelian scholasticism was under pressure from four directions: its logic was attacked as over-complex and artificial; its rational theology as verbal sophisms not needed by the faithful and not cogent enough to convince the faithless; its physics as abstract and unempirical; its system of values as ascetically self-mutilating. In his assault on contentious learning Bacon associated himself with all these criticisms.

The delicate learning of humanism had enjoyed a pathetically short life in England. Henry VIII executed Thomas More; Erasmus had left England by the time, with the death of Colet, that the English humanist group was beginning to dissolve. Erasmus and More, both apostles of tolerance, found their ideas swept away in the torrent of bloodthirsty religious frenzy initiated by Luther's Ninety-Five Theses of 1517. A tenacious educational ideal survived, as did a habit or practice of private cultivation. The scepticism derived from Sextus Empiricus which was the expression of humanism in formal philosophy did not take on at all as an elaborated doctrine until William Chillingworth, of Falkland's Great Tew circle, that civilised group of philosophically conversational

friends meeting in the Oxfordshire countryside so much admired for their enlightened moderation by Matthew Arnold, just before the civil war, delighted in Sextus' arguments a number of years after Bacon's death. In Bacon's own time it was represented in England only in anti-astrological polemics.

The new nature-philosophy of his age was seriously under-estimated by Bacon in being identified, under the label 'fantastic learning', with the esoteric occultism of Paracelsus and Fludd. Bacon is commonly criticised for a lack of response to the really significant natural science of his own period (see Chapter 9). It could just as well be argued that he failed to take account of the impressive body of philosophical theorising about nature between Nicholas of Cusa, who died a hundred years before Bacon was born, and Bruno, who died at the stake in 1600.

Bacon's map of his intellectual environment was, then, seriously incomplete in one respect. It was, all the same, comprehensive enough to be a reasonable guide and to reveal as unoccupied the region of ideas that Bacon was to make his own. That image of a map is appropriate to apply to the work of a thinker in, and very much of, the great age of discovery which inaugurated the spreading of the natural science of Europe to the rest of the world, and with it the technical and industrial transformation of traditional agricultural society. The Viennese historian of ideas Friedrich Heer writes that 'every English philosophy is a memorial to the political conditions of the time'. He goes on to say about Bacon that he 'was possessed by the hunger for power, possession, honour and influence. He wanted to hold the world in the palm of his hand. His drive to power made him the natural advocate of the inductive method and of an oppressive colonial and scientific policy. The inductive thought of Bacon was England's answer to Spain.' If there is anything to that, and the role of industrial primacy in England's historical mission as the final obstacle to continental European tyrants who go too far suggests that there is, there is more to Harvey's unkind remark that Bacon wrote science like a Lord Chancellor than its author intended.

3 The great instauration

It has usually seemed odd to those who have considered the matter that Kant should have dedicated his greatest work, the *Critique of Pure Reason*, to Bacon. Kant does claim to have been awoken from his dogmatic slumbers by an empiricist, by a philosopher who, like Bacon, saw sense-experience, and not reason, as the foundation of all real knowledge, namely Hume. But Kant is not, like Bacon, a partisan of inductive reasoning or, more generally, the propounder of a new method, except in philosophy itself. Where Bacon's aim was to revolutionise the scientific study of nature, Kant's was to consolidate the Newtonian system of the world which he saw as the crowning and completed achievement of science.

In the second edition of his *Critique*, Kant added a quotation to Bacon's name from the latter's preface to *The Great Instauration*, published in 1620 as a kind of grand ornamental approach to the *Novum Organum*, in which the formal details of Bacon's new method were set out.

Of myself I say nothing; but in behalf of the business which is in hand I entreat men to believe that it is not an opinion to be held, but a work to be done; and to be well assured that I am labouring to lay the foundation, not of a sect or doctrine, but of human utility and power. Next I ask them to deal fairly by their own interests . . . join in consultation for the common good . . . come forward themselves to take part in what remains to be done. Moreover, to be of good hope, nor to imagine that this Instauration of mine is a thing infinite and beyond the power of man, when it is in fact the true end and termination of infinite error . . . (G 247)

It is not hard to see that part of the appeal of this to Kant is in its confident claim to have brought men at last into the light from long and seemingly interminable enslavement to confusion. But more significant is the fact that Kant's quotation is from *The Great Instauration*. This promissory fragment of about twenty pages is the most ambitious, if not the most de-

tailed, of Bacon's displays of classificatory enthusiasm. Here there is a marked affinity with Kant, who divided his main philosophical project into three critiques, each themselves divided in an elaborately systematic way, and with gorgeous names for all the elements of the system.

Bacon's *Instauration*, or complete system of the sciences, was divided into six parts, actually carried out by him to very different extents and labelled in concrete Jacobean English where Kant relied on the utmost in professorial abstraction. The first part is the *division of the sciences*. In 1620 Bacon described this as 'wanting', although he admitted that some account of the matter would be found in the second book of *The Advancement of Learning*. In 1623 there appeared in Latin his *De Dignitate et Augmentis Scientiarum*, the revised and enlarged version of *The Advancement of Learning* that is usually referred to as the *De Augmentis*. It looks a little like the promised provision of a proper first part for the *Instauration*, but, as Bacon's great nineteenth-century editor James Spedding observes, if that is so it is odd that he did not call it something like 'Partitiones Scientiarum'. Perhaps it was still too like its English original of 1605 for his liking. For all his doubts it should be said that Bacon's classification of the sciences is one of the most thorough and without doubt the most influential things of its kind there has ever been. The intense devotion of the French *encyclopédistes* of the eighteenth century is not due only to his worldly concern with natural science and opposition to mystery. It owes something to their sense of him as a pioneer in the organisation of knowledge.

The second part of the project is the *Novum Organum* of 1620, further described as 'true directions concerning the interpretation of nature'. This is Bacon's principal work on what he saw, quite reasonably, as his most important achievement, his method for the acquisition of real knowledge of the natural world. Even here he shows some hesitation. He adds to the title phrase: 'not however in the form of a regular treatise, but only a summary digested into aphorisms'. It too, then, is in its author's eyes a second best, a series of notes for something more complete and worked-out. In this case nothing further was to

appear. But the *Novum Organum* is a fair-sized work, only a little shorter than *The Advancement of Learning*, and it is generally agreed that Bacon took more trouble with it than with anything else he wrote. He seems to have begun to write it about 1608 and it was not published until twelve years later. Its defects are not those of sketchiness or incompleteness.

The third part of the system is the 'phaenomena universi' or natural history. Bacon's intention here was to accumulate particular items of information in a methodically ordered way, ready to be subjected to the inductive techniques of the *Novum Organum*. Bacon made some progress with this part of his scheme in the form of his 'histories' of the winds, of life and death and of the dense and the rare. There is also the *Sylva Sylvarum* ('wood of woods' or collection of collections), on which he was working at the time of his death and which contains some very dubious material, lending some colour to the conception of Bacon as not much more than a particularly bold and ambitious exponent of the magical and mystical lore of his age. A celebrated item in it is his remark that 'the heart of an ape, worn near the heart, comforteth the heart and increaseth audacity'.

Neither the fourth part, 'scala intellectus, or the ladder of the intellect', which was to consist of fully worked-out examples of Bacon's method in action, to serve as instructive paradigms, nor the fifth, 'prodromi, or forerunners or anticipations of the new philosophy', which he describes as conclusions arrived at, not by the new method, but by 'the ordinary use of the understanding' and so 'for temporary use only', seem to have taken on any solid literary form. As for the sixth and last, 'the new philosophy, or active science', this was conceived by Bacon as work not for his own hands but for the subsequent generations of scientific inquirers, brought up in his method, and spreading out into all the regions of knowledge whose boundaries had been established in *The Advancement of Learning*.

A number of smaller philosophical works by Bacon can be regarded as preliminary to and sometimes as absorbed in the *Novum Organum*, such as his *Valerius Terminus*, his *Cogitata et Visa* and his *Temporis Parus Masculus*. The work of greatest

philosophical or scientific interest that is not a part of the In-stauration is the *New Atlantis* with its highly original con-ception of natural inquiry as an essentially co-operative undertaking.

In his own time Bacon was best known, as he is to students of literature today, for his *Essays*, of which several editions ap-peared between 1597 and the complete set of fifty-eight of 1625. The generalised, well-informed worldly prudence with which they abound is also a feature of *The Wisdom of the Ancients* of 1609 (translated into English in 1619), in which Bacon analyses the rational messages more or less hidden in the myths and fables of antiquity. Also worthy of consideration are his one substantial venture into history, the *History of Henry VII* of 1621/2, and various writings on legal subjects, notably *Maxims of the Law*.

My main concern in what follows will be with Bacon as a philosopher of science, and thus, above all, with *The Advance-ment of Learning* and *Novum Organum*. But some attention will be given to his ideas about law, politics and history and to his purely literary achievements and opinions.

4 The critique of false systems

Although the main business of *The Advancement of Learning* is the development of a classification of all the varieties of knowledge, that is only the topic of its second book, which is more than twice as long as the first. There are, as well, some preliminaries of varying degrees of importance. The first, and least, of these is an introductory passage in which the gifts and virtues of James I are praised with unappetising fulsomeness. There follows a more substantial defence of learning, or, more particularly, natural knowledge, against various sorts of detractors. In the course of this defence Bacon sets out his objections to the three kinds of fallacious learning mentioned already in the description of his intellectual environment. This criticism is briefly repeated in a somewhat different form in the consideration of the idols in *Novum Organum*, that is, the account of all the factors, innate, personal and social, which mislead men in the pursuit of truth. The fourth class of idols, the idols of the theatre, are the received systems of philosophy which get in the way of effective investigation of nature.

Bacon's defence first confronts the clergy with their frequent claim that the study of nature is impious. He relies here on his sharp anti-Thomist distinction between the study of nature and the study of the supernatural or divine. God, he says, 'worketh nothing in nature but by second causes', which is, in effect, to say that nature is a closed system from which nothing can be inferred, at any rate of a detailed sort, about God. 'We do not presume,' he says, 'by the contemplation of nature to attain to the mysteries of God.' 'Divers great learned men', he goes on a little later, 'have been heretical, whilst they have sought to fly up to the secrets of the Deity by the waxen wings of the senses.' Men cannot be 'too well studied in the book of God's word, or in the book of God's works, divinity or philosophy ... only let men beware ... that they do not unwisely mingle or confound these learnings together' (A I i 3.44–6).

After some pleasantly insubstantial material about the social and political harmlessness of learning, in which he draws comfort from the fact that Alexander the Great was Aristotle's pupil, he arrives at more serious business, by way of an amusing consideration of the mean employments and disagreeable manners of the learned.

The first to be examined of the false philosophies of the age is the delicate learning with its 'vain affectations'. This, in effect, is humanism and Bacon upbraids it for ornamental vacuity, for concentration on style at the expense of substance. Obsession with eloquence and the worship of Cicero are ridiculed but there is no very detailed account of what is being proscribed nor any clear boundaries drawn to it. Erasmus, for example, is cited as a witness against it, despite his indifference to the kind of natural investigation Bacon favoured.

What is overlooked, not surprisingly, in Bacon's critique is the idea that has grown in strength increasingly since the eighteenth century that the study of human affairs – the individual person, the intellectual and artistic products of man, the various kinds of human society – must be carried on by methods quite other than those applied in the study of non-human nature. This thought was first presented in a thoroughly worked-out way in the eighteenth century by Vico and in the nineteenth was the common conviction of a series of exponents of the autonomy of history. In our own age this belief in the methodological uniqueness of the human world has been applied to the social sciences, including psychology, as well as to history. It has been generally admitted, perhaps, that the humanities proper, the textual, literary disciplines whose place in the educational scheme of things is a consequence of humanism, are not natural sciences, susceptible of inductive treatment.

In Bacon's classification of the sciences 'history' is one of the absolutely primary divisions, along with 'philosophy' and 'poesy'. But what he is talking about is not history in our usual sense, although it includes it. For him it is that part of our mental activity concerned with the registering of particular, individual facts. By seeing it as the proper employment of

memory (as philosophy is of reason and poesy of imagination) he seems to concentrate on the storage of particular items of knowledge to the exclusion of their discovery, but his associations of basic kinds of learning with faculties of the mind need not be taken very seriously.

Under history Bacon includes both natural and 'civil' history, regarding both as storehouses of data for the corresponding types of philosophy, in other words for natural and social science. It is clear that he believes that his methods apply to man and society, that human and civil philosophy (psychology and social science) are inductive disciplines. The point is enforced by his open admiration for Machiavelli as a great innovator who added to knowledge by studying what men are and not what they ought to be. In a memorable image Bacon ends his account of the delicate learning by comparing it to 'Pygmalion's frenzy'. 'Words are but the images of matter; and except they have a life of reason and invention, to fall in love with them is all one as to fall in love with a picture' (A I iv 3.54). The scientifically-minded still quite often feel like that about the humanities.

In my earlier consideration of the humanism of Bacon's age I claimed that the strictly philosophical expression of it was scepticism, most notably expounded for Bacon by Montaigne. Bacon mentions Montaigne approvingly in the first of his essays, the one on truth, and it is generally supposed that he chose to call his brief prudential writings 'essays' in polite imitation of Montaigne. Decartes's friend and impresario, Marin Mersenne, regarded Bacon as a sceptic himself because of his assault on the Aristotelian tradition.

Bacon criticised the contemporary admirers of the Pyrrhonians reported by Sextus Empiricus only in passing. He no doubt felt a sense of affinity with them, seeing them as engaged, as he was, in the destruction of scholastic orthodoxy. In the discussion of logic in *The Advancement of Learning* he mildly chides some 'academical' philosophers for going too far. In the *De Augmentis* version he says, 'their great error was, that they laid the blame upon the perceptions of the senses, and thereby pulled up the sciences by the very roots. Now the senses,

though they often deceive us or fail us, may nevertheless, with diligent assistance, suffice for knowledge . . . But they [the sceptics] ought rather to have charged the defect upon the mind . . . and upon false forms of demonstration' (D 504).

A point to notice here is that the scepticism of the ancient world was much more concerned with the logical than with the perceptual sources of error and contradiction. In modern times, however, under the dominating impulse of the scepticism from which Descartes begins his philosophy, interest has fastened almost exclusively on the senses and memory. Bacon did not foresee this shift of focus, largely because he helped to create the conditions for it by insisting that the ultimate source of all real knowledge is sense-perception, not intuitions of self-evident truth. In his view the sceptics of his time were critics of deductive logic. Where he differed from them was in the attitude inspired by that criticism. They thought that if deductive logic was empty and formal no knowledge could be secured. He thought that he had a new logic with which to replace the old one. Thus he rejected their pessimism about the possibility of knowledge but did not blame them for it.

So although Bacon admits the fallibility of the senses – 'the impressions of the senses,' he says, 'are erroneous, for they fail and deceive us' – he does not see this as a major difficulty of principle. For he goes on, 'we must supply defects by substitutions, and fallacies by their correction', which suggests that all that is needed is another look to make sure. That would not satisfy scepticism of Descartes's kind, which says that we can never be sure that we are not dreaming or the dupes of an evil demon. He prefers scepticism to dogmatism but maintains that 'when the human mind has once despaired of discovering truth, everything begins to languish . . . But . . . we are not to deny the authority of the human senses and understanding, although weak, but rather to furnish them with assistance' (N I 67.274).

The second, and most important, object of his criticism is the contentious or disputatious learning, which 'did chiefly reign among the schoolmen: who having sharp and strong wits, and abundance of leisure, and small variety of reading, but their

wits being shut up in the cells of a few authors (chiefly Aristotle their dictator) as their persons were shut up in the cells of monasteries and colleges, and knowing little history, either of nature or time, did out of no great quantity of matter and infinite agitation of wit spin out unto us those laborious webs of learning which are extant in their books' (A I iv 5.55–6).

Bacon does not accuse the scholastics of deficient intelligence or motivation, allowing them 'great thirst of truth and unwearied travail of wit'. But to this they did not join 'variety and universality of reading and conversation'. So, 'as they are, they are great undertakers indeed, and fierce with dark keeping', neglecting 'the oracle of God's works', that is to say the natural world accessible to the senses, and adoring 'the deceiving and deformed images which the unequal mirror of their own minds, or a few received authors or principles, did represent unto them' (ibid.).

The obscure verbal splendour of this attack should not be allowed to conceal its argumentative limitations. It is, indeed, a largely rhetorical appeal to the age's mood of anti-traditional prejudice. In *The Advancement of Learning* Bacon does specifically instance the scholastic habit of attention to the subjects about which speculation and controversy are bound to be fruitless, namely supernatural ones, but that claim rests on a largely unargued if not unreasonable thesis about the effective limits of the human mind's operation. More crucial is his objection to scholastic method in which every thesis is at once subjected to refutations which are really only distinctions and which in turn excite further objections and distinctions in a kind of interminable to-and-fro of debate that amounts to 'monstrous altercations and barking questions' (ibid.).

There is a little more logical substance to Bacon's critique of scholastic disputatiousness in the first book of *Novum Organum* when he is considering it as one of the idols of the theatre. Aristotle, he says, 'corrupted natural philosophy by logic', he 'imposed innumerable arbitrary distinctions upon the nature of things; being everywhere more anxious as to definitions in teaching and the accuracy of the wording of his propositions, than the internal truth of things'. In the course of this

criticism he does give some particular examples of Aristotelian error but does not show that they are erroneous. In saying that Aristotle wrongly 'treated of density and rarity . . . by the frigid distinctions of action and power' he does not produce an argument, only an abusive adjective (N I 63.271).

There is, of course, something seriously wrong with Aristotle's theory of the physical world, in its more commonsense terrestrial part as well as in the more obviously ridiculous celestial-cum-theological part. Very much more sensible ideas about the earth and the heavens were in circulation in Aristotle's time – those of Democritus, the great exponent of atomism, in particular – but they sank into oblivion and were not revived in any detail until shortly after Bacon's time by Gassendi, who somehow managed to reconcile being a priest with adhesion to the materialist philosophy of Democritus and Epicurus. On the other hand, if the term 'scholasticism' is interpreted with reasonable width to mean, not just Thomism, but medieval Christian philosophy in general, then it is not true that scholastic philosophy of nature was simply a reiteration of the physics of Aristotle. Ockham's insistence on the contingent nature of God's creation meant that we could not understand the natural world by scrutinising the purposes we could ascribe, by a priori reasoning, to God. It is necessary to observe what actually happens if we are to find out how God has arranged things. From this beginning the disciples of Ockham went on to develop a kind of mathematical physics that anticipated the form of the great seventeenth-century systems of the world from Galileo on.

An elementary criticism of Aristotle's philosophy needs to do two things: to produce an articulate account of the limitations of deduction and to fasten attention on the manner in which the axioms from which deduction proceeds are arrived at. Even if the logical theory available to Bacon was rudimentary, the idea that deduction does not provide genuinely new information but only extricates and renders explicit what is already contained in its premises was a familiar one. J. S. Mill's affronted objection that the syllogism (which is effectively all deduction in the Aristotelian tradition) is emptily question-

begging was a standard Pyrrhonian manoeuvre, accessible to any student of Sextus Empiricus.

Aristotle did indeed maintain that a true science is a deductive system which must start from axioms or first principles that are both general and self-evident. The usual conviction of empiricist philosophers, modern or traditional, is that general propositions can be self-evident or irresistibly certain only if they are conceptual in nature and not substantial truths of fact. Bacon did not take this view and perhaps did not consider it a possibility. He called any process by which a general proposition is arrived at induction, and objected to the inductions of the scholastics on grounds of haste and over-eagerness, not because of any objection of principle.

Thus a standard empiricist would say that a science of natural fact must begin from reports of particular items of fact on which the science's general propositions or theories depend for their support. Since the theories always go far beyond the singular items of evidence they rest on, they can never, in a factual science, satisfy the Aristotelian requirement of self-evidence or certainty. Bacon, on the other hand, believed that certainty could be obtained by induction just as long as it was gradual and methodical. For him, then, the Aristotelians were doing the right sort of thing, but not enough of it. For other, later empiricists, they are doing the wrong sort of thing, namely relying on observation to supply or suggest general truths that are self-evident, certain and necessary.

One very important point Bacon does make in a slightly indirect way in his critique of disputatious, scholastic learning. In *Novum Organum* he attacks too much respect for the systems of antiquity, saying, 'nor must we omit the opinion, or rather prophecy, of an Egyptian priest with regard to the Greeks, that they would forever remain children, without any antiquity of knowledge or knowledge of antiquity; for they certainly have this in common with children, that they are prone to talking, and incapable of generation, their wisdom being loquacious and unproductive of effects' (N I 71.276). In *The Advancement of Learning* he says 'antiquity deserveth that reverence, that men should make a stand thereupon and discover what is the best

way; but when the discovery is well taken, then to make pro-
gression.' He goes on, in the spirit of his observation that the
ancients were really children, 'these times are the ancient times,
when the world is ancient, and not those which we account
ancient *ordine retrogrado,* by a computation backward from
ourselves' (A I v 1.58).

This point of view is absolutely opposed to the governing
conception of knowledge of the medieval philosophers. They
saw themselves as orderers and preservers of knowledge, not as
its creators. In the first place they took the knowledge that it is
most important for human beings to have, that which concerns
the divine governance of the world and human prospects of
eternal life or damnation, to have been authoritatively revealed
in the scriptures and authoritatively commented on in the
writings of the fathers of the Church, particularly Augustine.
Secondly, when the main bulk of Aristotle's work made
its circuitous way to the West it was received with a gen-
erally submissive reverence. Aquinas regarded 'the Philosopher',
as he called Aristotle, as an unquestionable authority in any-
thing that did not directly conflict with the articles of
faith.

Even if the humanistic philosophers of the Italian Re-
naissance rejected Aristotle, it was not to make room for fresh
ideas of their own. They merely switched allegiances among the
philosophers of the ancient world and came forward as the
disciples of Plato. It is understandable, no doubt, that devout
and orthodox Christian thinkers should see the past as superior
to the future, or, at any rate, the terrestrial future. The idea of
man's fall from initial perfection that is embodied in the story
of Adam and the garden of Eden is a potent and concrete
instance of the idea of a golden age in the past. Something like
that idea is present in Plato with his account of the predestined
stages of degeneration in the life of states and his belief that
decay can at best be staved off by the rigid prevention of
change.

Bacon is the most confident, explicit and influential of the
first exponents of the idea of progress. J. B. Bury, the historian
of that idea, could find only slight and soon obliterated traces of

the belief in progress before Bacon: a momentary scintillation in Democritus that was not perceived by his Epicurean successors, a rather stronger hint in Bacon's medieval namesake, Roger. Bacon's progressivism is the outcome of two strains in his thought. The first of these is his more or less unprecedented notion of knowledge as cumulative. The second is his insistence that knowledge is for practical use, specifically for 'the relief of man's estate'.

In order for knowledge to be thought of in this way, as something to be constantly added to, a new conception of true, basic, paradigmatic knowledge has to be adopted. Bacon took that step by his clearly proclaimed diversion of interest from the divine to the natural. There is a parallel, attractive to some intellectual tastes, between Bacon's view of knowledge and the capitalist conception of wealth. Both replace the idea of a fixed, exhaustible stock, liable to decay and in need of careful preservation, with that of an interminable flow of human contrivance.

Bacon is often dismissed, with a measure of intellectual snobbery, as a mere propagandist for a natural science he did not understand. There is a point in that criticism. Bacon did not grasp the essential role of mathematics in the major scientific advances of his age. But in his belief in the possibility of large and continuous growth of knowledge, of finding new knowledge rather than retrieving old knowledge before it disappears irrecoverably, he played a crucial part in creating a mental atmosphere or environment in which the natural-science-centred conception of knowledge could flourish. This is the ultimate bearing of Bacon's attack on the disputatious learning of the scholastics and supports the claim that it is the most important of the three.

The third and last of the defective kinds of learning that Bacon assails is the fantastic learning which is the uncritical acceptance and dissemination of marvels and fables, the most colourfully obvious form of the interest in the natural world of the thinkers of the Renaissance. Bacon's definition of what he has in mind under this head is not very precise. He gives as examples of 'admitting things weakly authorised and warranted', miracles 'wrought by martyrs, hermits, monks of the

desert, and other holy men' in ecclesiastical history and 'fabulous matter, a great part not only untried, but notoriously untrue' in natural history. He also deplores giving too much credit to dubious sciences and authoritative persons, as well as to particular reports. 'The sciences themselves,' he says, 'which have had better intelligence and confederacy with the imagination of man than with his reason, are three in number: astrology, natural magic and alchemy.'

What Bacon has to say about these dubious sciences is more penetrating than his vaguely hostile gestures in the direction of reported marvels. He allows that the ends of these sciences are noble, namely the mastery of nature for human purposes, but holds them to be 'full of error and vanity', which their exponents seek to conceal by 'enigmatical writings ... auricular traditions and such other impostures'. He neatly compares the alchemists' search for ways to turn base metal into gold with the story in Aesop of the father who told his sons gold was buried in the vineyard so that they dug it into unprecedented fertility in their pursuit of what was not literally there. 'The search and stir to make gold hath brought to light a great number of good and fruitful inventions and experiments' (A I iv 9–11.57).

An important point lies behind Bacon's not very argumentatively formulated distaste for the esotericism of the practitioners of the fantastic learning. This is that publicity is essential for valid scientific work, the exposure to the criticism of others of the evidence and reasoning on which the findings claimed are based. This is a different aspect of the conception of science as a social undertaking from that for which Bacon is best known. In his *New Atlantis* Bacon foresees the co-operative character of the scientific research of later ages, the type of institution in which the principle of the division of labour is applied to the work of natural investigation. But the pursuit of methodical economy and efficiency is a comparatively superficial proposal. The idea that criticism of scientific findings is indispensable if they are to be rationally acceptable is altogether more far-reaching.

The contention that science must be *critically*, and not just

co-operatively, social is a central idea of the most influential of
contemporary philosophies of science, that of K. R. Popper. 'If
scientific objectivity were founded ... upon the individual
scientist's impartiality or objectivity, then we should have to say
good-bye to it ... science and scientific objectivity do not (and
cannot) result from the attempts of an individual scientist to be
"objective", but from the co-operation of many scientists ...
First, there is something approaching free criticism. A scientist
may offer his theory with the full conviction that it is unas-
sailable. But this does not necessarily impress his fellow scien-
tists; rather it challenges them. For they know that the scientific
attitude means criticizing everything ... Secondly, scientists try
to avoid talking at cross-purposes.'

Popper often refers to a traditional conception of science to
which he is firmly opposed as 'Baconian'. But although this is
not a misnomer, it does obscure some important matters of
agreement between them. That science should ideally seek, or at
least be institutionally constrained to undergo, external criti-
cism is not the least of these.

As for Bacon's critique of the uncritical acceptance of indi-
vidual reports of marvels or oddities, it does not, in itself,
amount to much. But it points the way to a familiar re-
quirement of scientific method as it has developed since his
time, that experiments and, where possible, observations should
be *repeatable*. In logic a general hypothesis of the form *All A
are B* is proved false by the discovery of a single A which is not
B. But that such a discovery has been actually made is not
established by the occurrence of an honest report that some
observer believes he has come upon an A which is not B. We
are not infallible observers. Before an observation can be
allowed to carry significant weight in relation to our theories it
needs to be authenticated.

Bacon maintained that scientific inquiry ought to be co-
operative in a methodical, institutional way. In so far as it rests
on the individual observations of innumerable observers it is
bound to be informally co-operative. Indeed, more generally,
very much the greatest part of what each human being believes
or claims to know rests on the authority of someone else. Tes-

timony is the staple food of our cognitive diet, even if it needs to be supplemented with the salts or vitamins of our own direct acquisitions of knowledge. The problem of testimony, of the conditions under which it is rationally acceptable, has been little examined by philosophical theorists of knowledge. The most penetrating consideration it has received has been as a secondary aspect of Hume's inquiry into miracles. Bacon is no exception and is content to deplore rather than to investigate the credulity of the adherents of the fantastic learning.

No one would suppose that Bacon is a crypto-scholastic or that he is a humanist devoted to Cicero or Plato. But it is quite often said, despite his attacks on it, that he is really an exponent of the esoteric, magical lore of the Renaissance himself. J. H. Randall Jr says, 'in truth in his positive doctrine he belongs, not with the sciences – for he rejected mathematics and the new astronomy – but with these gropers after fantastic learning'. And, a little later, he repeats the charge: 'he merely organized and codified the crude experimentalism of the Renaissance fantastic learning'. According to Friedrich Heer, 'Bacon dreamed of an alchemistic universal science.'

This is too extreme. Of course there are pieces of fabulous and highly questionable matter floating about in the large body of Bacon's writings, such as the belief, mentioned earlier, in the therapeutic qualities of an ape's heart. But he is not blind to the merits of Aristotle and his scholastic followers and the influence of humanism is manifested both by his respect for Plato and by the conscious elegance of his writing. It is true that Bacon achieved nothing significant in the way of direct scientific inquiry and that he was a poor judge of the really important scientific developments of his own age. But, in the broadest sense, he understood the nature of modern natural science better and more explicitly than anyone in his epoch. The character of that method altogether removes him from the neighbourhood of Paracelsus and Fludd.

In his positive doctrine Bacon gives a central position to the views which conflict with the three erroneous systems he has criticised. Against the speculative deductions of scholasticism he argues for a cautiously gradual inductive procedure, based

on systematic observation by the senses. Against the gentlemanly scholarship of the humanists he supports the co-operative mechanical experimentation of the scientific researcher. Against the secret and haphazard undertakings of the occultists he proclaims the need for publicly criticisable and methodical investigation of nature.

5 The idols

A more familiar part of the negative, critical preliminaries to Bacon's philosophy of science than his assault on received systems is the doctrine of idols, in the first book of *Novum Organum*. The idols of the mind are various widespread tendencies of the human intellect which explain its frequent lapses into error. He arranges them in four, colourfully named, classes as the idols of the tribe, the cave or den, the market and the theatre.

The idols of the tribe are mental weaknesses more or less universally typical of the human species. Those of the cave are individual peculiarities, which are nevertheless widely found, serving to distinguish one cast or style of mind from another. The idols of the market are the forms of error that can be traced to the influence of language, whose properties we are inclined to read into the world it is supposed to describe. The idols of the theatre are the received but erroneous systems of philosophy which have been considered in the previous chapter.

The idols of the tribe include the mind's tendency to suppose 'a greater degree of order and equality in things than it really finds' (N I 45.263), to ignore exceptions to principles that are generally accepted or pleasing to believe, to be over-influenced by what strikes it suddenly or excitingly, to carry on in a particular direction of thought even where there is no factual support for it and thus to end in such pseudo-explanations as those by final causes, to be swayed by emotions and, most important of all, to be led into falsehood by 'the dullness, incompetency and errors of the senses' (N I 50.267), as a result of which we are led to ignore the more subtle, delicate and invisible changes in the natural world.

The idols of the cave or den are, naturally, even more of a mixed bag. Men tend to apply the concepts and principles of their special interest to everything else. Some are apter at discerning differences; others, likenesses. Some revere antiquity;

others love novelty. Some are obsessed by details; others by the whole.

The idols of the market are, in Bacon's view, the most troublesome. Words mark the most visibly obvious, not the most explanatorily significant, differences between things. As well as words that are 'confused, badly defined and hastily and irregularly abstracted from things' (N I 60.269) there are words that stand for nothing, like '*Fortune,* the primum mobile, the planetary orbits, the element of fire, and the like fictions' (ibid.), but these are the less obnoxious and easier to deal with of the two.

The idols of the theatre were described fifteen years after the forms of vain philosophy were discussed in the *Advancement of Learning,* and the two lists do not exactly coincide. The sophistic philosophers are Aristotle and his scholastic disciples, who rely too much on logic applied to uncriticised common assumptions. The 'empiric' philosophers make use of experiments, but too precipitately. Bacon gives the alchemists and William Gilbert, theorist of magnetism and first user of the word 'electricity', as examples, an unfortunate juxtaposition for his reputation as a student of form. Finally, there is the 'superstitious' school who corrupt philosophy by mixing it with superstition and theology. These are not the humanist exponents of the delicate learning. Who they positively are is not easy to determine. No clearly demarcated group of thinkers is identified by Bacon's formula.

The study of precisely definable formal errors in reasoning is as old as logic itself. Aristotle, who turned into a science what had previously been an unsystematic accumulation of rules, included a treatise on fallacies, *De Sophisticis Elenchis,* in his logical writings. Bacon's theory of idols inaugurates something of the same very general sort, but much more comprehensive. It is not simply an album of popular false beliefs and superstitions like Sir Thomas Browne's *Pseudodoxia Epidemica,* (1646) the initiator of a series of public enlighteners of a more or less 'rationalist' kind leading up to Ackermann's *Popular Fallacies* and Mackay's *Extraordinary Delusions.*

It is closer to such non-scientific books on the art of thought

as Graham Wallas's book of that name, or to an aspect of them.
It is, more exactly, a general pathology of thinking with not
much more than an appearance of system and completeness. Its
main utility cannot be preventative, except in the most diffuse
fashion, as an inclusive warning to the incipient theoriser of all
sorts of hazards ahead. It does supply a handy catalogue of
explanations of why some piece of thinking has gone wrong.
But it cannot by itself show that any bit of reasoning is de-
fective. The weaknesses it enumerates are not guaranteed in all
cases to lead to error. Much invalid reasoning rests on analogy,
the favoured mental process of Bacon's devotees of re-
semblance. But so, also, do some discoveries of the greatest
importance, such as the atomic theory of matter.

One particular analogy has been invoked to interpret Bacon's
theory of idols in a suggestive manner. Bacon, it is said, re-
tained from his puritan upbringing a sense of the fallen nature
of man, but transposed it from the moral to the intellectual
realm. We have certain very real and potentially fruitful intel-
lectual capacities. But so far we have largely misused them,
whether from greed, or idleness, or the intellectual pride that
induces men to try to solve problems that are beyond them.

On this interpretation Bacon saw himself as an intellectual
saviour, come to call sinners to the appropriate kind of re-
pentance and, even more, to compensatory good works in the
future. Like others with a saving message he is an optimist, not
just in believing, truly, that he would have an effect, but that he
would liberate men from the errors of the past and set them on
a path in which the attainment of knowledge would be unob-
structed by mistakes.

That idea represents him as more naïve than he was, as
supposing that all the obstacles to knowledge are psychological.
Bacon was, in fact, clear that nature is much more complicated
than the human intellect that tries to decipher it. He did believe
that if we are cautious, methodical and co-operative we can
attain some certain knowledge of nature. But to suppose we can
come to admit nothing but the truth is not to imagine we can
ever get the whole truth.

In our own age there is something of a fashion for revelling

in the non-rational or even superstitious sources of great scientific achievements, such as Kepler's painful move from the conviction that heavenly bodies must move in circles, in view of their perfection, to his laws of elliptical planetary motion. Less mischievous is the view that scientific hypotheses are imaginative constructions, as spontaneous as works of art at their best, and that their origins in general or particular deficiencies of the human mind are irrelevant to their validity. If that is so, there is no need to uproot the idols; the method of science is used not to replace them but to make a rational selection from the competing theories they induce us to put forward.

6 The classification of the sciences

Bacon's classification of the sciences is to be found in the second book of *The Advancement of Learning* and, in a considerably enlarged and elaborated form in books ii to ix of the *De Augmentis*. The main structure of the classification remains practically unaltered. It is as if a set of rooms had been provisionally furnished and then, over the years, more and more things had been disposed around the rooms, without any serious builder's work being carried out on them.

What Bacon says he is classifying is the varieties of learning, rather than sciences. Science proper, or philosophy as it is called in the earlier treatment, is only one of three main varieties recognised, but it receives ten times as much attention as history (a term Bacon uses pretty much in our sense). History, in turn, occupies nearly four times the space allotted to poesy. The basis of this ultimate threefold distinction is a distinction between three faculties of mind, conceived, presumably, as being specially relevant to learning. History relies on memory, poesy on imagination, and philosophy on reason.

Poesy, which he deals with second, seems to be an interloper here. It is not a primarily or obviously cognitive undertaking. We do not ordinarily go to it to add to our knowledge or modify our beliefs, although it may have such an effect tangentially. Furthermore, history and philosophy, in Bacon's sense, as knowledge of individual facts and of general laws, are necessary to each other. As Bacon so strongly insisted, the general laws of nature must be derived by inductive reasoning from individual facts of the kind that history, as he interprets it, records. Correspondingly, the laws of logic and of nature must be invoked in the critical examination of historical claims, where they are tested for consistency with each other and with the general run of things.

Bacon's general formula for poesy is 'feigned history', in prose as well as in verse. It gives men satisfaction by allowing

them to contemplate what nature has failed to provide. It is a device for more or less edifying wish-fulfilment, for it submits 'the shows of things to the desires of the mind' (A II iv 2.88). Its subdivisions are into the narrative, the representative, and the allusive or parabolical. (In the *De Augmentis* the representative gives way to the dramatic, which, Bacon observes, is greatly fallen from its dignified position in the ancient world.) In the later book he spends most time on parabolical poesy, that in which some philosophical idea is concretely illustrated. It is this form of poetry which is most cognitive, closest to history and science.

The individuality and generality of their findings are a better basis for Bacon's distinction between the two essentially cognitive parts of the realm of learning than their respective assignment to memory and reason. To start with, the two mental faculties are not properly co-ordinate, since memory, unlike reason, is a store, not a source, of knowledge. The source of individual facts is perception or observation, conceived broadly enough to include our perception of our own states of mind. Furthermore scientific or philosophical reasoning relies on memory, both to supply its premises and as the preserver of the capacity of reasoning.

Besides this division in terms of individuality and generality there are two other forms of distinction which constantly recur in Bacon's system of classification. The first of these is that between the theoretical and the practical, between knowledge and action, or, in his terminology, between the speculative and the operative. This is applied through all the main branches of philosophy or science, but not to history, which he plainly conceives as a register of evidence for various sciences, theoretical and practical, but not as having any lessons to teach us on its own.

Secondly, there is a distinction between the divine and the non-divine, which itself divides, a little indefinitely, into the natural, the human and the civil (or social). The indefiniteness is due to the fact that, while he usually puts the natural and the human side by side (for example, as the two main kinds of non-divine philosophy), the civil is treated as a species of the

human, and both spheres of investigation are held amenable to the same methods as non-human nature, except that the question of the nature and substance of the soul, as contrasted with its faculties, is remitted to revealed religion (which is divine knowledge or *scientia*, but not philosophy at all). It is probably correct to take these uncertainties as indicating a measure of embarrassment on Bacon's part at his removal of religious matters from the region of serious inquiry.

The major category of history in Bacon's system is not much more than a list. It is subdivided into natural, civil, ecclesiastical and literary kinds. The latter, understood widely as a history of learning, Bacon sees as wanting in his own time and much to be desired. It is calculated to 'make learned men wise in the use and administration of learning' (A II i 2.79–80). In the *De Augmentis* he says that it and ecclesiastical history are to be seen as parts of civil history (D 427).

Natural history is of 'creatures, marvels and arts' (A II i 3.80). The second is required, not for open-mouthed amazement of the sort once produced by Ripley's *Believe-It-Or-Not* or other such 'Mirabilaries', as Bacon calls them. It is, rather, to fasten attention on exceptions to common assumptions and as an aid to technological ingenuity: 'from the wonders of nature is the nearest intelligence and passage to the wonders of art' (A II i 4.80).

Civil history can be imperfect, that is, be the material of historical study in a raw state, whether it be as 'memorials', official documents and personal memoirs, or as 'antiquities', even rawer material, such as monuments, names, proverbs, tales. History proper, which he calls 'perfect history', is of three kinds: chronicles of epochs, lives of people, narrations of actions. In the course of this discussion he turns aside to address James I, to whom the books are dedicated, to suggest that a history of Great Britain, or at least of the Tudor period, is highly desirable now that the crowns are united. By the time these observations were repeated in the *De Augmentis* in 1623 his *History of the Reign of Henry VII* had come out.

Despite its title this is not simply the chronicle of an epoch, nor even the life of a particular monarchical person. It is an

instance of the type of history Bacon most favoured, an analytic and explanatory study of a connected sequence of actions and events: the establishing and centralising work of the Tudor dynasty. Bacon was led by his Machiavellian realism about politics to seek causes rather than to describe the ceremonial surface of public events. His own historical work, that is to say, was not a mere feat of memory or bald registration of the past. It undermined the distinction he himself drew between history and philosophical or scientific knowledge proper.

The study of this third and favoured category of learning is the main topic of the second book of *The Advancement of Learning* and it takes up all but one of the eight corresponding books of the *De Augmentis*. There is one slightly peculiar feature in this classification, testifying once again to Bacon's discomfort about religious knowledge. At the outset he divides knowledge (or *scientia*) into divinity and philosophy. But the divinity he has in mind here is 'inspired', or as we should say, revealed, theology and not natural or rational theology, the derivation of religious conclusions by rational argument, which Bacon calls 'divine philosophy' and sees as co-ordinate with 'natural philosophy' (for us, natural science) and 'human philosophy' (for us, the sciences, or study, of man and society).

On the whole Bacon allocates all the detail of religion to the domain of authoritatively revealed theology and remits it, from indifference or respect, perhaps both, to the end of his discussion, where it trails behind everything else a little forlornly. Of natural theology he says, 'it sufficeth to convince atheism, but not to inform religion'. He goes on, a little later, 'but . . . out of the contemplation of nature, or ground of human knowledges, to induce any verity or persuasion concerning the points of faith, is in my judgement not safe . . . we ought not to attempt to draw down or to submit the mysteries of God to our reason; but contrariwise to raise and advance our reason to the divine truth' (A II vi 1. 91–2). He ends his brief discussion of natural theology with the remark that far from there being too little of it there is far too much. Its entire business, in his view, is to infer from natural facts that God exists. With a distinctly grudging admission that it is legitimate to inquire into the

nature of angels and spirits, he moves on to the more agreeable topic of natural philosophy.

Just before this somewhat parenthetic treatment of natural theology there is a moderately turgid passage about *philosophia prima*, first philosophy, the main content of the *Metaphysics* of Aristotle. The branches of knowledge, he says, meet, like those of a tree, in a stem, not a point, and so we should acknowledge a universal science at the base of all the particular sciences. However, when he considers what goes by the name, he finds 'a certain rhapsody of natural theology, and of divers parts of logic; and of that part of natural philosophy which concerneth the principles, and of that other part of natural philosophy which concerneth the soul or the spirit; all these strangely commixed and confused' (A II v 2.90).

That anti-metaphysical, positivistic comment is not Bacon's final word on the subject. A tamed and humbled first philosophy is acceptable, one that confines itself to the role of 'a receptacle for all such profitable observations and axioms as fall not within the compass of any of the special parts of philosophy or sciences, but are more common and of a higher stage' (ibid.). The examples of its theses are something of a mixed bag: if equals be added to unequals the results will be unequal (seen as a maxim of arithmetic and of law); what God has made is perpetual, we cannot add to or subtract from it; 'is not the delight of the quavering upon a stop in music the same with the playing of light upon the water?' (A II v 3.90–1).

After this piece of musing and the bleak immuring of natural theology the serious business begins. Natural philosophy has a speculative or theoretical side, for Bacon, as for us, natural science, and an operative or practical side, which he asks leave to call by the provocatively alchemical name of natural magic. The first is 'the inquisition of causes'; the second 'the production of effects'. Each of these two sides of natural philosophy is further subdivided: natural science into physic and metaphysic; natural magic or natural prudence into 'experimental', 'philosophical' and 'magical' forms.

Physic is natural science proper, as it has been understood since Bacon's time. It is concerned with material and efficient

causes. Metaphysic, on the other hand, is concerned with formal and final causes. This reference to the traditional four causes of Aristotle is less than perfectly straightforward. The material cause of a thing is simply the matter of which it is made; the efficient cause is that which makes the thing in question out of the material. In so far as causal explanation is concerned with the making of things each of these kinds of causes is necessarily involved. But most interest in causes fastens on events that happen to things, changes in their characteristics and position, not on their coming into existence. In such cases there is an efficient cause, an antecedent event that brings about the change, but no clear or useful application for the idea of a material cause. In fact Bacon makes little use of the notion of material cause. Physic, for him, is essentially the study of efficient causation in nature.

The final cause, part of the business allotted to metaphysic, is the purpose for which a thing is made (or, one could add, changed or moved). Bacon is rightly understood to have been an inveterate and influential enemy of the doctrine of final causation. 'The handling of final causes,' he says, 'mixed with the rest in physical inquiries, hath intercepted the severe and diligent inquiry of all real and physical causes, and given men the occasion to stay upon these satisfactory and specious causes, to the great arrest and prejudice of further discovery'. He does not here deny that natural events have final causes, that they are, in other words, the intentional outcome of the purposes of an intelligent being. Final causes are 'true and worthy to be inquired, being kept within their own province; but ... their excursions into the limits of physical causes hath bred a vastness and solitude in that tract' (A II vii 7.96).

This does not, he protests, 'call in question, or derogate from divine providence', it highly confirms and exalts it. Nevertheless there is something badly adrift in Bacon's position. Metaphysic has been detached from the abstract universal science of *philosophia prima* and also from natural theology. All that can be rationally inferred from the contemplation of nature is *that* God exists, not what he is like, far less what his purposes are in minute detail. Yet final causes, the investigation

of the intention of God as revealed in the natural world, is claimed to be a proper object of the rational discipline of metaphysic. Lack of candour, expressed as a desire to leave standing as much of the intellectual tradition, or its terminology, as possible, has led to a muddle. Whether Bacon believes that natural events in general have final causes or not, he cannot consistently maintain that they are a proper object for rational inquiry. The pursuit of final causes is just a proscribed form of that natural theology from which Bacon has been anxious to distinguish metaphysic, as a science or discipline wholly concerned with the natural world.

Here, with metaphysic as with physic, one of the alleged types of cause proprietary to it is redundant, the other essential. Metaphysic, for Bacon, is the science of formal causes. What he means by that traditional expression is a central problem of interpretation in his philosophy of science and will be the topic of Chapter 8. But it is at least clear that it does not mean what it initially meant for Aristotle.

For him everything consisted of matter and form, the marble of a sculpture and the human shape that makes it into a portrait. If that shape is considered on its own in a somewhat fanciful way it is possible to bring oneself to see it as somehow bringing about its own realisation in the statue of which it comes to be the shape. In the case in hand, which is insidious because of its combination of simplicity and untypicalness, the human shape can easily be thought of as somehow in the sculptor's mind, perhaps as a schematic visual image, before he externalises it in the statue. That is not possible with a child or a sapling, but people have got themselves to conceive that the adult human or arboreal form these things will come to have, if they develop fully to their perfect or completed state, is somehow lurking implicitly within them, perhaps as a 'programme', in the technological jargon of our day.

That is not Bacon's idea at all. To express his position briefly and dogmatically: the forms, for which it is the business of metaphysic to search, are the hidden states of the fine structure of things by reference to which their straightforwardly observable properties can be explained. His theory of forms is at its

most developed in the second book of *Novum Organum*. But already in *The Advancement of Learning* its importance is dimly discernible. He rejects the ordinary anti-Platonic view that 'the inquisition of man is not competent to find out essential forms' (A II vii 5.94). Plato was right in taking forms to the 'the true object of knowledge', and mistaken only in considering them as 'absolutely abstracted from matter'.

This way of putting his point is not illuminating. His real conviction is that there is an underlying simplicity in the order of nature, far from evident in the colourful and multiform variety it exhibits to the senses. Just as the formation of words becomes readily intelligible when they are understood as made up of a modest handful of simple elements, the letters of the alphabet, so the vast array of different kinds of substances in the world becomes intelligible when understood as the product of the action or working of a limited variety of forms.

Where metaphysic, then, finds out the simple, but hidden, formal causes of things, physic deals with their obvious, but complex, efficient causes. These last he sometimes calls the *variable* causes of given effects, because a cause of this sort, for example rubbing, will have one effect on one kind of substance, a different one on another, making glass shiny and suede matt. The complexity of physic is overcome in metaphysic by tracing all the various efficient causes of a given kind of effect to a single common, but unobvious, factor that is present in them all. His acceptance of this role for metaphysics is his answer to Mill's problem of the eliminability of a plurality of causes.

It is not necessary to linger over his subdivision of physics into three parts, concerned, in the *De Augmentis* version of the doctrine, with the 'principles', the 'fabric' and the 'variety' of things. What should be noticed is the operative or practical disciplines he takes to correspond to the two main branches of speculation or theory. To physic corresponds mechanic, to metaphysic, magic (in the *De Augmentis* at any rate, where there is no mention of a low-grade experimental kind of operative natural philosophy as there is in *The Advancement of Learning*). It is to natural magic, and not mechanic, that we must look for any major technical achievements, he believes.

'There can hardly be discovered any radical or fundamental alterations or innovations of nature, either by accidents or essays of experiments, or from the light and direction of physical causes; but only by the discovery of forms' (D 474).

There is still one more important component of natural philosophy, according to Bacon, namely mathematics. It is, he says, an 'appendix', not a substantive science. He has to insist on this 'by reason of the daintiness and pride of mathematicians, who will needs have this science almost domineer over physic' (D 476). He distinguishes between its pure and 'mixed', or applied forms: arithmetic and geometry on the one side, 'perspective, music, cosmography' and many more on the other.

It has long been a familiar, and well-founded, criticism of Bacon's philosophy of science that it does not adequately recognise the role in science of mathematics. It is in a strictly quantitative study of the properties of natural objects and events that natural science, in his own time as in ours, largely consists. Bacon has no real sense of this fact. He remains, in this respect at any rate, an unregenerate Aristotelian.

His view that mathematics is an auxiliary and not a substantive science is an early, and not very convincingly articulated, version of what was to become an empiricist orthodoxy. In modern times it is contrasted, as a formal or conceptual science, with factual sciences such as physics and biology. Along with his empiricist successors Bacon associates mathematics and logic, but gives no determinate account of the relation between them, where later thinkers have seen logic as the proto-science of which mathematics is the continuation, or as a part of mathematics, specifically as a sort of algebra.

Even if he is right about the dualism of the formal and the factual, which many well-informed critics would deny, that does not overcome the criticism that he does not recognise the *indispensable* place of mathematics in science. An auxiliary can still be an essential auxiliary, and of that he shows no awareness.

Human and civil philosophy covers all the rest of Bacon's system of classification. It is a markedly mixed bag, suggestive here and there, but of much less depth, interest and influence

than the non-human part of the system. He accepts the distinction of mind and body in a wholly unreflective and uncritical fashion, giving no account of what the basis or principle of the distinction is. He is in favour of the study of human nature, but mainly in the form of the study of the relations between mind and body, of how each works on the other and of how each reveals what is going on in the other. Physiognomy studies how body 'discloses' mind; 'exposition of natural dreams' shows what is revealed about the body by the 'imaginations of the mind', an even more reductive discipline than Freud's dream-interpretation.

The sciences of body are divided, fairly whimsically, into medicine, 'cosmetic' (which includes hygiene), 'athletic' (the old Greek gymnastics) and the 'voluptuary' arts (which in the *De Augmentis* primarily consist of a kind of psychological aesthetics, which is far from a purely bodily inquiry in Bacon's sense).

Turning to the sciences of the mind Bacon remits investigation of 'the substance or nature of the soul or mind', with a little reluctance, to religion. 'This knowledge,' he says, 'may be more really and soundly inquired, even in nature, than it hath been', but 'in the end, it must be bounded by religion' (A II xi 1.109). The soul was inspired by God into the body, not extracted from the general mass of the material world, and so is not subject to the laws of nature. Two disciplines associated with elevated conceptions of the soul are more or less swept under the carpet as discreditable in practice, even if not to be condemned absolutely because of religious support. One is divination, foretelling the future; the other is 'fascination', the exercise of influence on physical things by the soul without the use of its own body.

There are, however, some rational and respectable sciences of the mind. They deal with the soul or mind, not in itself, but through its operations, in particular with the faculties of understanding and will. The first of these is logic, very broadly conceived; the second is ethics, also taken comprehensively. In the *De Augmentis* he explicitly uses these terms and they are disquieting. For logic and ethics are not factual sciences, co-or-

dinate with physics and metaphysics as Bacon conceives them. He himself refers to the four logical disciplines he distinguishes as *'arts* intellectual', not as sciences.

` What he actually offers, in place of the psychology of thought and will the reader has been led to expect, is a collection of rules for the right, proper and effective ordering of man's intellectual and volitional life. In terms of one of his own basic distinctions, these amount to operative or practical, rather than speculative or theoretical, disciplines. One could even call them *technologies*, of thinking and of conduct, with a little metaphorical licence. Now in the domain of non-human natural knowledge operative rules depend on speculative laws. It would be reasonable to expect a parallel speculative basis for the intellectual and moral 'arts' in the human domain, but nothing of the sort is provided.

In this failure to distinguish between the normative, rule-propounding arts of logic and ethics, on one side, and the factual science of psychology, cognitive and volitional, on the other, Bacon, it might be said, is doing something commonly objected to in later British empiricists, most notably Locke and Hume. Locke's *Essay concerning Human Understanding* sought to study the workings of the human intellect by the 'historical, plain method', the method of observation and inductive generalisation that would make the study of mind an empirical science. Hume described his *Treatise of Human Nature* as 'an attempt to introduce the experimental method of reasoning into moral subjects', which, in current English, means 'an attempt to apply empirical methods to the study of the mind'.

But Locke and Hume went about the task in a more resolute way and with a clear idea of what an empirical discovery about the mind is. Both started from the factual generalisation that all our images are copies, whether directly or as a result of combination, of sensations we have previously experienced. They wrongly took this to be equivalent to the epistemological thesis that for a word to have meaning it must be connected to a type of sensation or experience, which is the criterion of its application. Underlying the belief that the generalisation and the

epistemological thesis are equivalent is the mistaken conviction, endlessly seductive in its simplicity, that the meaning of a word, a concept, an element of our thoughts, is an image.

There is nothing of this in Bacon. He strides cheerfully forward into a discursive account of the traditional disciplines of logic and ethics, ornamenting them with many curious and frequently interesting additions, but without really doing anything to work them into a shape congruous with the requirements of his system. That he did not succeed in achieving a clear idea of the relation of logic and ethics, as usually understood, to the empirical psychology of the relevant aspects of mind is no disgrace. The only clear notions of the relation are plainly erroneous: that the two terms are identical, and its opposite extreme, that the two terms have nothing whatever to do with one another. But he should have done something to digest these borrowings from tradition. It was left to Hobbes, his sometime amanuensis, and to Locke and Hume to carry his governing idea forward.

Logic, as Bacon conceives it, is very closely similar to the trivium of logic, grammar and rhetoric that was the fundamental element of the medieval university course in arts. He divides the subject into four parts: invention, judgement, retention and the conveying (or 'tradition') of knowledge. The science of judgement is logic in the ordinary, comparatively narrow sense, that is, the discipline concerned with 'proofs and demonstrations' (A II xiv 1.117). Here the topic is only deductive inference, and specifically the syllogistic inference codified by Aristotle, where the premises necessitate the conclusion. Bacon attaches quite as much importance to the study of fallacies as to the systematisation of valid forms of reasoning. In the dicussion of this subject in *The Advancement of Learning* (A II xiv 9–11.118–20). Bacon gives a first sketch of his theory of the idols of the mind that was considered in Chapter 5. That theory, it should be said, does have a reasonably factual character, being a kind of empirical pathology of the intellect.

Retention either is absorbed into 'tradition', the general study of language and expression, or consists of practical tricks which

Bacon does not think much of, but believes could be greatly improved on. Tradition, the conveying of knowledge, covers a lot of interesting ground: linguistics in an embryonic state, grammar and rhetoric. Phonetics, cryptography, stylistics make brief, rudimentary appearances. Advice on the reading of books and the instruction of the young figures as appendices to the subject.

Bacon's central interest in the field of the 'arts intellectual' is in what he calls 'invention' and particularly in invention of arts and sciences, rather than of 'speech and arguments' (A II xiii 1.111–12). He sees it as hitherto largely deficient. Traditional, deductive logic 'doth not pretend to invent sciences, or the axioms of sciences' (ibid.). The induction of which the philosophers of the past spoke as the supplier of 'the principles of the sciences' is 'utterly vicious and incompetent' (A II xiii 3.113–14). What he here objects to is induction by simple enumeration, where the mere accumulation of favourable instances is taken to justify the corresponding general law, whereby from *This cow eats grass* and *That cow eats grass* and *The other cow eats grass* it is inferred that *All cows eat grass*. 'To conclude,' Bacon says, 'upon an enumeration of particulars, without instance contradictory, is no conclusion, but a conjecture' (ibid.).

In his discussion of 'that knowledge which considereth of the appetite and will of man' (A II xx 1.133). Bacon attacks what has previously been offered as being too grandiose and unpractical; it is 'a certain resplendent or lustrous mass of matter, chosen to give glory either to the subtility of disputations, or to the eloquence of discourses' (A II xx 2.133). What is needed are 'Georgics of the mind' so as to 'instruct and suborn action and active life' (A II xx 3.134).

Bacon considers that knowledge of what is good is to be found in adequate detail in the writings of past moralists. The question of how we come to know what is good does not trouble him. Yet he recognises a large measure of disagreement among proclaimed moral authorities, and judges the issues involved in a firm, confident way. Aristotle is wrong to prefer contemplative life to action. The Stoics and Socrates are right to value virtue for its own sake and not simply as a means to

pleasure. Epictetus is reproved for neglecting the moral value of good intentions even where they do not succeed.

Bacon rests his criticism of Aristotle's contemplative ideal on a distinction between two kinds of goodness: 'the one, as everything is a total or substantive in itself; the other, as it is a part or member of a greater body' (A II xx 7.134). Applying this distinction to man, he concludes that 'the conservation of duty to the public ought to be much more precious than the conservation of life and being' (A II xx 7.135). This is a very commonplace observation. Bacon sees that there is a problem about inducing men to follow the moral course and pursue the common good. His great successor, Hobbes, took there to be no such problem about getting men to pursue their own interest or advantage, since it is impossible for them to do anything but what they believe will contribute to it. His task, then, is to argue that the path of social duty is, despite appearances, really in the best interests of necessarily self-regarding men.

The second part of Bacon's ethics, the 'regiment of the mind', a kind of technology of moral training or motivation, has no such theoretical basis. It simply rests on the fact that men do not act as virtuously as they should, even as virtuously as they admit that they should. Here, at least, empirical psychology makes a tentative appearance. 'The first article of this knowledge,' Bacon says, 'is to set down sound and true distributions and descriptions of the several characters and tempers of men's natures and dispositions (A II xxii 4.142). He sets out a programme of investigation into innate styles of personality, into the influence on character of age, sex and nationality, into the effects of good or bad fortune, into the sicknesses of personality and their cures. But he is content to illustrate this desirable science, without properly pursuing it.

The final part of human philosophy is 'civil knowledge'. Here, as in logic and, largely, in the individual part of ethics, practice is legislated for, without much attention to theory. Civil knowledge is more a technology than a science. Its first ingredient is 'conversation', essentially the technique of winning friends and influencing people, one which Bacon himself applied in a much too obviously technical way. Secondly, there

is 'negotiation or business', a set of recipes for the prudent management of one's affairs. These can be culled from the proverbs of Solomon, the letters of Cicero, traditional fables, the writings of Machiavelli and aphorists generally. Bacon's *Essays* are his own, rather substantial, contribution to the subject, which he memorably labels 'the architecture of fortune' (A II xxiii 37.162).

The third constituent of civil knowledge is government, which is treated in an unrelievedly practical and manipulative fashion. Laws, he says, should be considered by statesmen; not by philosophers, whose 'discourses are as the stars, which give little light because they are so high', nor by lawyers, since 'the wisdom of a lawmaker is one and of a lawyer another' (A II xxiii 49.166). With this, apart from a section on sacred and inspired divinity, that is to say revealed, and not rational, religion, his survey is complete. 'I have been content,' he says, 'to tune the instruments of the Muses, that they may play that have better hands' (A II xxiv.167).

In a prouder image, at the very end of the book, he says, 'Thus have I made as it were a small globe of the intellectual world' (A II xxv 25.175). Bacon's system of the sciences is indeed a map of knowledge, full of the exploratory spirit of the age, the main masses outlined, but with large, unknown tracts within them awaiting investigation, while many fabulous islands and continents have been obliterated. His 'human philosophy' is no more than a programme, with no real idea of what the empirical sciences of mind and society would turn out to be. Only with Hobbes are they recognisably inaugurated.

His account of natural philosophy is much more substantial. What he saw as its most important element, his theory of eliminative induction as the only valid method of arriving at the laws of nature, the next item in the catalogue of the 'Great Instauration', is worked out in detail in part II of *Novum Organum*. Before considering this, it is worth noticing that although his general scheme of classification suggests that human and natural philosophy are on the same footing, in their concrete description the two very greatly diverge. Human philosophy is almost wholly operative or technical, with only oc-

casional recognition of the need of such disciplines for a speculative or theoretical basis. But it is only such theoretical sciences which can arise from Baconian induction. His account of the human sciences fails to connect them with the new method which alone makes what is claimed to be a science really scientific.

7 The new method

The most important element of the first book of *Novum Organum* is the theory of the idols of the mind which was considered in Chapter 5. That discussion is preceded by a rapid sequence of concise aphoristic paragraphs urging the need for a new method of investigating nature. Bacon's main point is the worthlessness and infertility of the axioms or first principles from which the sciences have hitherto been derived. They are defective in two main ways. The one which Bacon's new method is particularly calculated to overcome is the excessive precipitancy of the step of generalisation by which they are arrived at. The other is the habit of reliance on common, every-day notions, an insufficiently penetrating discernment of the important likenesses and differences between things.

Baconian induction will lead to the most general principles, not in one wild generalising swoop, but by gradual ascent. The suggestion is that the systematic way in which the evidence is acquired and set out by the new method will free its users from the paralysing dependence of previous students of nature on the rough and ready conceptual equipment of everyday obser-vation. Its systematic nature is also calculated to 'level men's wits' (N I 122.297).

In a way the methodicalness of the method is almost as im-portant as its precise formal structure. The proper and regular recording of observations will preserve us from all sorts of il-lusions and blind alleys. The deliberate, business-like nature of the whole undertaking will ensure that it is cumulative. The true philosopher, Bacon says, must resemble the bee, not the ant, who merely collects, or the spider, who merely spins frail constructions out of itself. He and the bee combine what the others do separately and fruitlessly: extracting matter, and working and fashioning it as well (N I 93.287).

In the course of these rather scattered preliminaries Bacon makes an important point about the low esteem in which the

physical, experimental study of nature is held. He rejects the 'opinion, or inveterate conceit, which is both vainglorious and prejudicial, namely, that the dignity of the human mind is lowered by long and frequent intercourse with experiments and particulars, which are the objects of sense, and confined to matter; especially since such matters generally require labour in investigation' (N I 83.281). This negative snobbery about getting the hands dirty is the counterpart of the positively snobbish over-valuation of the so-called ancients, who, of course, are really the children of the history of thought.

Bacon, in view of his public eminence, brought prestige as well as intellectual support to the study of the natural world. Thus began a process which was continued by Charles II's helpful patronage of the Royal Society and is comically symbolised by the description of Robert Boyle, leading figure in the early Royal Society and a great admirer of Bacon, as 'the father of chemistry and son of the Earl of Cork'. Something was thus done to loosen the hold on the European mind of the ideal of cultivated life expounded by the philosophers of a slave-owning society, an ideal which placed abstract intellectual contemplation at the summit of human activities, a kind of parallel to the moral asceticism which despised and condemned the pleasures of the body.

In book II the new method of induction is set out in detail. Bacon's claim is that his method of induction is a crucial innovation because it is *eliminative*. Behind that claim is his justly famous remark: *major est vis instantiae negativae* ('in establishing any true axiom the negative instance is the more powerful') (N I 46.266). G. H. von Wright, the most thorough and scrupulous of contemporary students of induction, says about this: 'Laws of Nature are not verifiable . . . but they are falsifiable . . . It is the immortal merit of Bacon to have fully appreciated the importance of this asymmetry in the logical structure of laws'.

What Bacon is opposing in his enthusiasm for eliminative induction is induction by simple enumeration, which he takes to be the kind of induction expounded by Aristotle and relied on by his disciples. Aristotle does indeed explicitly consider complete or perfect induction, in which a general statement is

conclusively established by the verification of its particular instances. Perfect induction is possible only where the class of things referred to in the general statement is finite and accessible, as in *All George's wives had money of their own* or *All Minnesota towns with a population of more than 5,000 have a public library*.

Generalisations like these can be conclusively verified simply because they are no more than summaries of particular pieces of information. What happens in the more usual and interesting case where the general statement refers to an open and not a restricted class of things? Aristotle does not explicitly consider induction proper, the kind of inference which arrives at general conclusions about unrestricted classes, although he acknowledges something like it in a discussion of analogical reasoning.

The acceptance of a style of reasoning that has come to be called 'intuitive induction' has been ascribed to him on the basis of his views about the nature of science. He says that a science is a system in which conclusions are deductively inferred from axioms or first principles, which must themselves rest on something other than deductive reasoning. They must be general and they must be necessary, in that the predicate must mention an essential property of the subject. Each of these characteristics of axioms, as Aristotle understands them, rules out their being discovered by ordinary perception. The truths it establishes are contingent and singular.

It is concluded that there must be a non-inferential way of directly establishing truths that are necessary and general, and the name 'intellectual intuition' is introduced for it. Is there any such thing? There are alleged to be numerous examples of it: *Nothing can be red and green all over*; *Whatever has shape has size*; *Space has three dimensions*. It is said that we cannot discover such things without sense-experience, but that such experience alone is insufficient to establish them as necessarily true. For that we must rely on an intellectual grasp of the necessary connection of the concepts involved, such as red and green, or shape and size.

That is not the conception of induction that Bacon ascribes to Aristotle and his scholastic followers. What he has in mind is

simple enumeration, the derivation of an unrestrictedly general conclusion from a finite and perhaps very small collection of singular premises. These premises will report particular instances of the conjunction or connection asserted generally in the conclusion. Reliance on this highly untrustworthy procedure is abetted by one of the idols of the tribe. 'The human understanding,' he says, 'when any proposition has been once laid down ... forces everything else to add fresh support and confirmation; and although most cogent and abundant instances may exist to the contrary, yet either does not observe or despises them, or gets rid of and rejects them by some distinction, with violent and injurious prejudice, rather than sacrifice the authority of its first conclusions' (N I 46.265).

His objection to enumerative induction is simply its rashness and notorious fallibility. He believed that by taking account of 'the greater force of the negative instance' with an eliminative method of induction he could make possible the discovery of laws that were *certain*. This is a residual echo of Aristotle's requirement that the 'first principles' of the sciences should be necessary, as is Bacon's dismissal of enumeration as 'not reason, but conjecture'. It would generally be agreed that this requirement cannot be satisfied. The most usual position in recent philosophy is that any sort of induction in which the conclusion does not deductively follow from the premises can allow only for the confirmation of the conclusion by the premises, for its acquisition of a degree of credibility from them that is inevitably incomplete.

The first stage of the new method is the preparation of 'a complete and accurate natural and experimental history' (N II 10.307). This material is then arranged in 'tables'. To start with there is the table of presence. In it cases where the 'nature' or sensible characteristic being investigated is present are described, to supply an extensive and thoroughly reported account of its usual or typical accompaniments. Next, in the table of absence, cases where the accompaniments of the nature under investigation are present, but where the nature itself is not, are listed. Thirdly, in the table of degrees, cases are set out in which a greater or less amount of the nature in question is

accompanied by a greater or less amount of some other variable characteristic. Matters are speeded up by including in the table of absence only cases which resemble (except, of course, in respect of the absence of the nature being studied) the cases listed in the table of presence.

The raw evidential material is now ready for the vital operation of elimination or exclusion to be carried out. Only that which is present in every case listed in the table of presence, and only that which is absent from every case listed in the table of absence can survive exclusions. What is absent in one of the cases of presence cannot be a necessary condition; what is present in one of the cases of absence cannot be a sufficient condition. Bacon sees it as the task of his method to reveal something that is both a necessary and a sufficient condition of any natural qualities it is applied to.

Bacon develops the method in *Novum Organum* in terms of an elaborately worked-out example, that of heat. The rays of the sun appear in the table of presence and, because of that, it follows that the 'form' or underlying cause of heat cannot be something exclusively terrestrial. The rays of the moon figure in the table of absence for they are not hot, or, he has to admit, do not appear to be hot. To settle that doubt he proposes passing them through the strongest possible burning-glass on to a thermometer. If the rays of the moon are properly in the table of absence, if, that is, they really are not hot, we may eliminate light as the form of heat we are looking for. The conclusion he comes to is that heat is 'an expansive motion restrained, and striving to exert itself in the smaller particles' (N II 20.326).

In view of the disparaging remarks that have been made about Bacon's capacities as a scientist from his own time to our own, it is worth noting that what he said about heat is a very reasonable approximation to the theory established by Maxwell and Boltzmann in the nineteenth century that heat is molecular motion. The idea that heat was a stuff in itself, a subtle, weightless fluid called 'caloric', still had its defenders two hundred years after Bacon when Davy reported an experiment under the title 'Caloric does not exist'. (He also argued neatly for the view that the moon exerted an influence on the tides, and was one of

the first to conceive the geological theory of continental drift). On the other hand, it should be admitted that he showed no appreciation whatever of the place of precise numerical measurement in the investigation of heat. As well as being qualitative where it should have been quantitative, his account of heat was static where it should have been dynamic. For all the comparative subtlety of his theory of heat, it still concerned itself with what heat essentially *is*, rather than with what it, or matter endowed with it, *does*. In Bacon's thoughts about heat there is really little inkling of thermodynamics.

Bacon's claim about his style of eliminative induction is that, by its utilisation of negative instances, it can arrive at certain and irrefutable laws, where enumerative induction is for ever at the mercy of a counter-example. In practice he is a bit less confident. He calls what is derived from a well-organised natural history of some nature by the 'exclusive' use of his tables a 'first vintage'. Its imperfection, in his view, derives from that of the concepts with which the natural world is described in the register of natural history. 'If we have not as yet good and just notions of simple natures, how can the exclusive table be made correct?' (N II 19.322).

His residual doubt about his method in practice, then, is that we are not in a position to apply it to adequate raw material. It is not that the available evidence may be unreliable. He admits that our senses are not to be trusted without any precautions, but believes that they can be used to correct themselves and be assisted by instruments. His point is that the likenesses and differences picked out by our sense-bound apparatus of description may well fail to discern the features of things that are really explanatory of what we perceive. This is a very direct consequence of his conception of the kind of cause that theoretical natural science proper, or 'metaphysic', should seek to discover. He does not, like Mill, see science as concerned to find observable antecedents for what we are interested in. Its aim, he supposes, is to unveil latent structures, which will inevitably be hard or impossible to observe.

Bacon's notion of forms or formal causes, to be considered shortly, is responsible for the imperfection in his method that

he acknowledges. Before turning to it, other, more abstract and more inescapable difficulties must be noticed. As a host of critics has observed, Bacon assumes that there *is* a cause for every nature or natural property we can observe. To assume that is to assume that nature is causally orderly, is a deterministic system. Many philosophers have tried to prove that it is (though without much agreement that they have succeeded in doing so). Others, like Kant, have argued that it is a 'necessity of thought' that we should believe that it is (although orthodox quantum physicists seem to get away with denying it, as does anyone who believes that chance is an aspect of the nature of things and not simply a reflection of our ignorance). Bacon takes the determinacy of nature unquestioningly for granted.

A second difficulty is that even if the assumption of determinism, that every kind of thing or event does fall under an explanatory law, were correct, it does not follow that the causal factor, thus guaranteed to *exist* in every case, should be discoverable by us. It does not follow from the fact that every event has a cause that any such cause is sufficiently simple or near at hand or observable for us to record it in our register of evidence. The imperfection Bacon admits can be seen as a special case of this difficulty. It is a difficulty, furthermore, which stands in a close relation to the previous one about determinism. The more we restrict determinism by formulating it in terms of discoverable causes, the less plausible it becomes. It is not possible to come near to refuting conclusively the claim that every event has some cause or other, however obscure and complex it may be. But we could have very good reason to believe that something was not caused by any simple, observable factor, close to it in space and time.

There is a conflict in Bacon's idea of the relations between nature and the human understanding which has led commentators to say apparently contradictory things about it. Many have quoted his remark: 'the subtilty of nature is far beyond that of sense or of the understanding' (N I 10.260). But others have seen Bacon as assuming that nature is not all that complex, that, in particular, there is a manageably small variety

of ultimate causes behind the complex multiformity of observable nature. In fact, both are correct. Nature is subtler than mind for Bacon. It is subtler than the senses since the forms that govern it are not obviously and straightforwardly observable. It is subtler than the understanding, which cannot work out on its own what the underlying order of nature is. But, he believes, if the mind is assisted by the right method certain knowledge of that underlying order can be achieved. There is nothing in Bacon of the idea, suggestively expressed in recent times by Chomsky, that the truth about the world might be of a level of difficulty that our minds, as practical contraptions hammered out in the process of evolution, are intrinsically unable to conceive.

Bacon's theory of forms led him to ignore all the respects in which causes, allowing that all or most events have them, might be hard or impossible for us to discover. The unobservable character of the forms, as has been mentioned, implies that they are calculated to escape description and registration. But he also fails to see that causes may be spatio-temporally remote from their effects, and complex in ways making them hard for us to grasp because of his conception of form. He sees the form of an observable characteristic as strictly contemporaneous with it. (Given the natural assumption that causal influence is conveyed by processes with a finite velocity, it follows from this that cause and effect must be in the same place as well). Finally, he always supposes that the true formal cause is an elementary, unconditional feature of the particles of which matter is composed.

In this last respect Bacon's position is less satisfactory than Mill's. Mill pointed out that causes could lack simplicity in two ways, by *plurality*, the case where many different factors can independently bring about a given effect, and by *complexity*, where a given effect can be brought about only by a conjunction of causal factors. Mill, indeed, thought the plurality of causes to be eliminable in principle, that further investigation would always reveal an underlying common element in apparently different independent causes. Bacon explicitly ruled out complex causes in Mill's sense, at any rate from 'metaphysic', in

other words theoretical natural science. For him it was a defect of 'physic' that it typically gave the cause of an effect only relative to a given substance, as when whiteness is seen as the effect of heating in the case of egg-white, but of pulverising in the case of glass. In short, Bacon's theory of forms assumes away in advance the main difficulties that beset induction when it is conceived as a method of acquiring certain knowledge.

On the whole Bacon's interpreters in recent times have made unnecessarily heavy weather of his theory of forms. The distinguished historian of logic, W. C. Kneale, says, 'unfortunately this doctrine is extremely obscure'. W. R. Sorley says, 'he gives many answers to this question [viz. what 'form' means], and yet the meaning is not altogether easy to grasp'.

It is really quite clear that what is meant is a latent structural property of the particles of which matter, according to Bacon, is composed. (Bacon is not strictly an atomist; he rejected the idea of empty space, like Descartes). It is an arrangement or configuration of matter, not a thing in its own right. It is, as has been seen, a necessary and sufficient condition of the sense-quality, or observable 'nature', that it is invoked to explain, and it is simultaneous with its effect. Forms are not observable, antecedent sufficient conditions like Mill's causes; nor antecedent necessary conditions as are the parts of the complex causes of events which we usually single out colloquially as the cause *simpliciter*. They are not events or processes, but states.

Bacon's forms are not, then, the causes that have been given most consideration by later philosophers, particularly in the empiricist tradition of Hume, Mill and Russell. They are, however, much more like the basic explanatory factors in modern physical science than the accessible, phenomenal causes of Hume and Mill are. Bacon anticipates an aspect of scientific development that empirically-minded philosophers from Hume to recent times have neglected: the preoccupation of natural science with fine structure. Locke's account of secondary qualities such as colour and taste in terms of the primary, largely spatial qualities of the microscopic parts of bodies is a less satisfactory, because more philosophically confused, recognition of the point that Bacon sees as central.

Nevertheless, Bacon's forms are different from the fine-structural explanations of natural science in being qualitatively conceived, and not as susceptible of numerical measurement, and as being static, persisting conditions of things, not events or processes in the history of their interactions with other things.

There are some aspects of Bacon's account of forms which make it easy to see why philosophers should have often so laboriously misunderstood him on this topic. By calling his underlying causes *forms* he puts some readers in mind of Plato, so that they think of them as abstract or mental. But his forms are physical, in that, like most of Aristotle's, they are embedded in matter. Secondly, he says at times that the form is identical with the quality or nature whose form it is, and he sometimes describes the search for form as a search for a definition. His prime example of heat is useful here. He can be seen in that discussion as working towards the discovery of *what heat really is*. That would succeed if something was found which is present when and only when objectively based experiences of heat took place. To do that is not to find what the word 'heat' really means, although it is to find a better meaning than the everyday one, a meaning that the word could come to be given.

Now and then Bacon says that the form of a nature or sense-quality is a *law*. In saying that the form of A is B he is propounding a law of a logically reciprocal form to the effect that everywhere and only where there is A there is also B. But the form B is not itself a law, only connected by law to the nature A whose form it is. Finally, he talks in a way calculated to mislead philosophers when he calls the form of something its *essence*. This at once suggests that it is an immaterial abtraction and that to give the form of a nature is to redefine it. But his positive account of form is really explicit enough to neutralise these misunderstandings.

There is a certain tension between Bacon's view that forms are the ultimate objects of scientific inquiry and his insistence on the practical usefulness of scientific knowledge, his anti-classical belief that knowledge is not for contemplative enjoyment but for the relief of man's estate. But that tension between

theory and practice is not an inconsistency. It is, rather, to take the position that the best and most fruitful practice must be based on theory that penetrates deeply beneath the surface of things. The history of science supplies abundant instances of the way in which apparently purely theoretical speculations lead in time to practical consequences that are as good as inconceivable without them.

For nuclear weapons the physical theories of Einstein were needed, and for Einstein's physics the mathematical constructions of Riemann, a century earlier. A less sombre example is the dependence of radio and television on Maxwell's equations. To make the point in Bacon's verbally provocative but not altogether inappropriate phrase, there is such a thing as 'natural magic', that is to say, the production of effects not just by the modification of their observably regular antecedents, but by the exercise of influence on their hidden internal constitution.

The last pages of *Novum Organum* are taken up with a long discussion, almost as shapeless and digressive as that paradigm of Renaissance lore, Burton's *Anatomy of Melancholy*, of what he calls 'prerogative instances'. There are no less than twenty-seven of these, and at N II 21.327, where they are first introduced, they are only the first of nine enumerated 'helps of the understanding with regard to the interpretation of nature'. The book ends before any of the other eight are considered.

In a way the main importance of the doctrine of prerogative instances is negative, as an admission by Bacon that he recognises that the tables alone will not yield the certain knowledge of the laws of nature which he believes it to be somehow possible for us to obtain. In the light of the prerogative instances that possibility becomes very diaphanous. The pursuit of these in all their variety is represented as an open-ended business, an aid to the more rapid elimination of explanatorily irrelevant factors, indeed, but not as a systematic procedure that could be brought to completion. The doctrine, then, reveals Bacon's doubts about the certainty which he felt that a proper method for the investigation should be able to secure.

Those doubts are well-founded, and for many more reasons

than Bacon recognised. He concentrated on our inadequate ideas of 'simple natures', namely those qualities of things that are really significant for scientific understanding. But, since his time, the most crucial objection to the idea that induction can certify its conclusions is the very same unverifiability of the unrestricted general statements in which the laws of nature are expressed which it was such a merit of Bacon to have stressed.

In fact, the prerogative instances are not particularly well-judged as devices for improving our conceptual apparatus. They are presented, as in the middle of the last paragraph but one, as aids to the more rapid elimination of erroneous explanations. Among them are 'solitary instances', where the property in question is present with none of its usual accompaniments. That, of course, will allow them all to be eliminated as necessary conditions. If there are any solitary instances of a property it can have no form in Bacon's very exigent sense. A *nearly* solitary instance, however, could do a great deal of eliminative work.

Others he lists are 'migrating' instances, where the property in question is observed to come into or go out of existence, that is, to be acquired or lost by something; 'conspicuous' instances, where the property in question is present in its most intense or purest form; 'instances of the cross', or what we call crucial experiments, in illustration of which he develops a very shrewd and elegant argument about the influence on the tides of the moon. Along with these are comparative odds and ends like the 'instances of the door or gate', which are mechanical aids to the senses like microscopes and telescopes. As the catalogue proceeds, any earlier intimations of a common principle are steadily eroded by the increasing miscellaneity of the items listed. The reader is left at the inconclusive end of the book with a series of more or less useful and perspicuous hints for the investigator of nature.

One of the most influential aspects of Bacon's thinking about science was the conception of a research establishment. This was set out, in a fanciful way, in the fragment of Utopian fantasy, *New Atlantis*, written a couple of years before his death and published a year after it in 1627 by his first bio-

grapher, William Rawley. The narrator is one of a ship's crew lost in the South Seas, without food and weakened by sickness. Very cautiously allowed to land on Bensalem, an unknown island (where quarantine regulations are in force), they find that the inhabitants, in the normal manner of Utopians, are remarkably chaste and do not accept tips.

What it all leads up to is the institution called Salomon's House, or the College of the Six Days' Works, set up by a Solon of the community long before, when he used its remoteness to hide it from the world's contagion. Bensalem trades only in light, that is knowledge, or, more precisely, it imports knowledge without paying for it, by means of a kind of industrial espionage.

More important is the cognitive home product of Salomon's house. Its purpose is 'the knowledge of causes, and secret motions of things; and the enlarging of the bounds of human empire, to the effecting of all things possible' (S 277). In pursuit of this end there is a large and varied array of appropriate structures and facilities: caves, towers, lakes, experimental laboratories and gardens, zoos, aquaria, kitchens, furnaces, enginehouses and everything else a fertile imagination could dream up for the object in question.

But the real interest of Salomon's house lies in the allocation of its personnel to particular tasks in a co-operative undertaking. Some travel, some extract material from books, some carry out experiments, some organise the findings of the experiments in tables, some work on technical applications, some devise new experiments, and some, finally – the interpreters of nature – develop the findings of the rest into organised theory.

A quainter and less fruitful anticipation of the future occurs in the very last pages of the fragment, a system of rites and ordinances not unlike the religion of humanity devised by Comte, but even more concentrated upon science and technology, the statues all being of inventors.

The seminal idea in Bacon's story about Salomon's House is that of the division of labour in science. It is sometimes said, indeed, that Bacon is the first exponent of the idea of the division of labour. A distinction needs to be drawn here between

the view, central to Plato's social theory, that differences in natural aptitude require the division of labour, and Adam Smith's more sophisticated view that the complexity of production requires it, independently of differences in aptitude (with the recognition of which Smith's point is perfectly compatible). Smith made his version of the principle memorable with his example of the manufacture of pins. A group of men, each carrying out one of the constituent operations in pin-manufacture, could produce 48,000 pins a day. Working as individual pin-fabricators they would produce only 200. Bacon, it could be argued, anticipated Smith's version, not so much because he says nothing in *New Atlantis* about the qualifications of his various types of specialist, but because of his belief that his method would level men's wits.

It is generally agreed that the idea of Salomon's House was at work in the minds of those who founded the Royal Society and, generally, it can be seen as standing in much the same, more or less grandfatherly, relation to institutionally organised scientific research as Plato's *Republic* does to monasticism. But although its exposition of the virtues of co-operation in scientific work is agreed to have been beneficial, the associated neglect of, or indifference to, the solitary business of individual exercise of the imagination in science has come in for criticism, most notably from Popper. His view is that scientific discovery cannot be mechanised, turned into a straightforward methodical routine to be carried on by any trained scientific craftsman, because important scientific advances are made by the creation of novel theories, not the mere summarising of observations.

That is true and important as an objection to the idea that all science is a matter of craftsmanly co-operation. But Bacon does seem to have a special place in his system of scientific trades for the framers of hypotheses: those interpreters of nature who are mentioned last in his catalogue and in what seems to be a position of special honour. But nowhere in his detailed account of the proper scientific method they are to apply is there any explicit recognition of the irreducibly unregularisable work of the creator of hypotheses and theories.

The limitations of Bacon's theory of science will be con-

sidered shortly when his leading critics are surveyed. Looking back over it as a whole we may conclude that he maps the character and programme of a genuinely natural science of nature, independent of religion, unencumbered by the authority of past speculation, unified by a method of eliminative induction that is set out in fairly thorough formal detail, to be carried on in a co-operative fashion for the material benefit of mankind. As natural, it is free from theology and metaphysics; as social, it is untouched by occultism and fantasy; as methodical, it transcends the desultory accumulations of antiquarian scholarship. In these respects, at any rate, it constitutes as important a step forward as any towards the governing conception of the world of the modern epoch.

8 Human philosophy

It was pointed out in the discussion of Bacon's classification of the sciences that he did not effectively develop his professed principle that the same empirical and inductive method should be applied to man and society as to nature. The account he gives of logic, ethics and 'civil knowledge' in *The Advancement of Learning* represents them as arts, or even technologies, as operative or practical disciplines. There is no exposition of the theoretical sciences on which, for conformity with his doctrine about the two aspects of natural philosophy, they ought to rest.

He was, of course, quite right to see logic, ethics and 'policy', the art of prudent conduct in private life and politics, as practical or normative disciplines. Where his inventiveness failed him was in the matter of delineating in the abstract the theoretical correlates on which they should be based. The interesting thing is that he did better, from the point of view of his own principle of the comprehensiveness of the inductive method, in his practice as a student of human affairs than as a detached anatomist of the possible and desirable varieties of that practice.

Thus, when he was actually engaged in writing history or about politics and law or, again, in the worldly moralising of the *Essays*, a grimly realistic and empirical spirit prevails. Recommendations about how to deal with human beings are firmly founded on a thoroughly unsentimental conception of human motives and characters. He was, indeed, a distinguished practitioner of some of the social studies: history, politics and jurisprudence. He made a much more significant addition to the stock of first-order knowledge about the world in the human sphere than he did in the domain of non-human nature.

His chief historical work is his *Reign of the History of Henry VII*, written very quickly after his fall from glory in 1621, presumably from previously assembled materials. It has been established with the utmost Teutonic thoroughness, by the German historian of the early Tudors, Heinrich Busch, that

Bacon's materials were not his own original discoveries, and that he relied for them almost entirely on the *English History* of Polydore Vergil, a protégé of Henry VII, published in 1533, nearly a quarter of a century after that monarch's death, and to a lesser extent on various Tudor chroniclers. More important is the fact that Bacon, for all his professions of scientific objectivity, used his materials very selectively and sometimes dishonestly.

Nevertheless, to suppose that if he is not an original source his sole importance as a historian derives from the excellence of his style betrays a pitiable kind of academic philistinism. What judgement would the egregious Busch have passed on Gibbon? In Bacon's time the writing of history in England was no longer the monopoly of monastic chroniclers. Their place had been taken by urban and lay chroniclers, culminating in Holinshed. Undigested material also accumulated in the work of a great generation of antiquaries. Thomas More's book on Richard III is a denigratory pamphlet. Bacon was the first analytic or explanatory English historian, since Polydore Vergil, the only possible earlier competitor for the description, was an Italian.

Bacon represents Henry VII as a cautious, suspicious and rational man, anxious to achieve his aims as cheaply and safely as possible. The reconstruction of the thinking that lay behind his manner of presenting himself to his new subjects after his victory in 1485 is nakedly and convincingly prudential. The prose of this book, incidentally, is much plainer and less ornamented than that of the *Advancement*, let alone that of the *Essays*. It is a working illustration of statecraft rather than an item of polite literature.

Bacon's political opinions are dispersed around various very different genres of writing. Half of the *Essays*, at their final count, deal with public affairs. There are also letters of advice to monarchs and ministers. He comes forward, not surprisingly, as the theorist of Tudor monarchy, but not as a supporter of the absolutism favoured by the Stuarts and above all by the first of them, James I. Bacon believed in a strong monarchy; advised but not in any way dominated by parliament; respectful of, but not exposed to the arbitrament of, the courts.

Judges, as he said in a famous phrase, should be lions, 'but yet lions under the throne' (E 803).

He saw great accumulations of wealth as unfavourable to the stability of the nation. He wanted the king, in accordance with a traditional idea, to be rich enough 'to live of his own', reserving serious taxation for public emergencies. There is an echo of the Machiavelli of the *Discorsi* in his belief that the highest life for a citizen is military, that there should be a citizen army and never mercenaries. He saw war, in a moderately unattractive analogy, as the exercise of states, a kind of bodily exertion essential to their health.

His hostility to lawyers, at least in their more overweening, politically ambitious aspect, was more than a by-product of his long-drawn-out quarrel with Coke. It is entirely in keeping with his rational progressivism, his dismissal of the presumption of the greater wisdom of the past, that he should scorn the retrospective obsession of lawyers with precedent. In the same way his exclusion of religion from the serious life of the intellect is congruous with his Erastian attitude to the church. C. D. Broad described him as 'a sincere if unenthusiastic Christian of that sensible school which regards the church of England as a branch of the Civil Service'. He advised Queen Elizabeth to water down the oath of allegiance so as not to compel reasonable Roman Catholics into treason, while agreeing that they should be excluded from office.

Bacon's animus against lawyers was in no way the expression of a sense of personal inadequacy as a lawyer. He was proud of his own abilities in his pre-eminently professional sphere, predicted he would in due time be seen as a better lawyer than his enemy, Coke, and received, in the end, an endorsement of this claim from the great historian of English law, Sir William Holdsworth, who said of him that he was 'a more complete lawyer than any of his contemporaries'. Holdsworth goes on to say of chapter 3 of the eighth book of *De Augmentis*, which is the most articulate presentation of Bacon's theory of law, that it was 'the first critical, the first jurisprudential, estimate of English law which had ever been made'.

Bacon lays characteristic stress on the need for certainty in law, seeing its absence as sometimes the result of there being no law in some area, sometimes of the obscurity of the law that there is. Obscure law leads to insecurity and to delay. The whole inherited mystery of the common law, with its immensely variegated constituents and its professional priesthood of devotional interpreters, suffered from what Bacon saw as the worst of vices in any human construction: inefficiency. He did not go so far as to recommend the complete codification of law. But he believed that English law should be digested, should have all obsolete, overruled and repetitive matter excised from it.

In his usual programmatic way this projected digest of the law should be accompanied by other works: a register of precedents, to be treated with respect, but not as binding authorities; a dictionary of legal terms; a volume of Institutes; and a volume, *De Regulis Juris*, listing fundamental legal principles, which he sketched himself in his *Maxims of the Law*, written in 1597 and published shortly after his death.

Bacon believed that the law should be efficient and cheap. He did not share the almost religious sentiments of many Englishmen towards their common law inheritance, and it was this attitude, incarnated in Coke, that was in the end to prevail, so that Bentham would react to the law of England in much the same way as Bacon two hundred years later. In the seventeenth century the common law was seen to be, and was, an obstacle to the arbitrary extension of the powers of the crown, something that was in part made inevitable by new circumstances, in part a matter of the Stuart dynasty's appetite for absolute power. Bacon, brought up under the more measured and cautious Elizabeth, did not see that danger, and was not minded to see absolutism as much of a danger anyway.

The historian Hugh Trevor-Roper regards Bacon as the clearest-sighted discerner of the critical problems of the monarchy in the early seventeenth century, above all the financial one of securing sufficient revenue to operate effectively. But his efforts to lead the crown to economic rationality, to curb its wastefulness, failed in face of the frivolous extravagance of

James I and the jewelled catamites he ennobled. Bacon, Trevor-Roper writes, 'diagnosed the evil – no man perhaps so completely'. In law and in politics, then, his good advice was not taken: unthinking traditionalism prevailed in the one, foolish and wasteful arbitrariness in the other. But, as Trevor-Roper goes on to show, he still exerted an important social influence through his ideas about education.

Bacon did not have much to say about education directly. As regards schools he does little more in explicit terms than recommend imitation of the Jesuits. He has more to say about universities, the objects of some lively invective in *The Advancement of Learning*, where he disparages the ancient scholastic exercises of wordy disputation, and proposes a style of education fit to produce capable statesmen in which history and politics take the place of logic and Latin. It was not until a couple of decades after his death that a Baconian educational doctrine was colourfully propounded by the Bohemian John Comenius, a somewhat mystical version of Bacon's views, as it turned out, derived from *New Atlantis* more than less fanciful works, and associating apocalyptic prophecy with such Baconian ideas as the need to attend to things rather than words.

But if Bacon himself said little directly about education as an institution, much is obviously implied by his writings, above all the need for the perceptual study of natural objects instead of unmitigated book-learning. For all his own religious indifference, his opposition to contemplative, aristocratic uselessness and his consequent concern with usefulness in the actual world were highly attractive to the growing spirit of moderate, non-fanatical Puritanism, for which sober productiveness and not millenial frenzy was the proper rule of life.

A general survey of Bacon's work cannot end without some reference to his more narrowly literary qualities and convictions. The contrast between the richness of his style and the plainness of his message is not by any means the largest paradox about Bacon, if it is a paradox at all. In his age to write well and to write strikingly were much the same; the self-effacingly 'natural' prose of Swift, the most perfect linguistic vehicle ever used for the conveyance of thought, was still far away. It

should be remembered that Sir Thomas Browne was to some extent a Baconian chastener of superstitious error and an even more colourful and ornate writer.

It is not just their somewhat artificial air of being exemplary exercises that makes Bacon's *Essays* less attractive than other, more earnest-seeming works that he wrote in English. Their aphoristic style of construction, a string of epigrammatic felicities printed as continuous prose, is tiresome. The impersonality which is brought into vivid relief by the comparison with Montaigne is, we feel, inappropriate to the form: impersonality is for the treatise or paper; the essay proper should be more confessional and intimate. Douglas Bush memorably said of Bacon's *Essays*, 'everyone has read them, but no one is ever found reading them'.

Inevitably Bacon's are not the very first essays in English literature, but they are the first to have become famous, and they have always remained so. Most people, one may well suppose, know more of them than they realise. As a quarry for anthologists of memorable sayings Bacon's *Essays* cannot rank far behind *Hamlet*. The first ten, which were published in 1597, were simply sequences of aphorisms and might have benefited from being printed on separate lines in the familiar style of the proverbs and psalms of the Old Testament. In the final edition of 1625 the number of essays had risen to fifty-eight and the senior members of the collection had been often considerably enlarged. The staccato series of aphorisms had been modulated into a much more continuous discursive flow by the inclusion of illustrative anecdotes and citations from classical literature, by digressive embroideries on the original theme, and by the provision of simple verbal devices of connection.

The insistently aphoristic nature of the original essays tends to reveal itself, despite these changes, in their arrestingly memorable first sentences: 'What is truth? said jesting Pilate; and would not stay for an answer', 'Men fear death, as children fear to go in the dark', 'Revenge is a kind of wild justice', 'The joys of parents are secret; and so are their griefs and fears. They cannot utter the one; nor will they not utter the other. Children sweeten labours; but they make misfortunes more bitter', 'He

that hath wife and children hath given hostages to fortune', 'It is a miserable state of mind to have few things to desire and many things to fear; and yet that commonly is the case of kings', 'Suspicions amongst thoughts are like bats amongst birds, they ever fly by twilight', 'God Almighty first planted a garden. And it is indeed the purest of human pleasures.'

Bacon's fondness for an aphoristic mode of expression is not just a bare idiosyncrasy of taste. He offers a defence of it in principle in the *Advancement of Learning* (A II xvii 6–7.125) as particularly suitable for the presentation of tentative opinions ('broken knowledges') and, in conformity with that idea, it is clear that he took the word *essay* in his first use of it in an etymologically primitive way, as meaning *attempt* or *experiment*. In later editions the more discursively expressed book was called *Essays or Counsels*.

The essays as a whole can be roughly divided into three main kinds: those which deal with public affairs, those which deal with particular aspects of private life, and those which deal with large abstract topics like truth and death, beauty and studies, revenge and the vicissitudes of things. The first group are comparatively practical and humdrum. At times, notably in the essay on usury, a lucid and competent piece of economic reasoning, they anticipate the impersonally rational style of exposition of the empirical social theorists of the eighteenth century. Bacon has sensible, only mildly unedifying views to communicate about the aristocratic order and social stability, the causes and cures of sedition, factions and negotiations, atheism and superstition, arrived at by careful and clear-sighted reflection on an ample experience of the matter in hand.

The cynical, reptilian side of Bacon is more evident, perhaps because less appropriate from the point of view of twentieth-century moral tastes, in the essays on such private topics as children and marriage (seen mainly as obstacles to worldly advancement), friendship and expense (friends are useful as receptacles for one's emotional overflow and as better critics of one's deeds than one is oneself), riches and ambition. An unusually sad experience of life is suggested by the remark,

'There is little friendship in the world and least of all between equals, which was wont to be magnified.'

It is the essays of the third group, dealing with large abstract ideas, that are deservedly the best-known. In them Bacon is freed from the fussy preoccupations of a high public official serving a third-rate despot, and from the obsession with advancement in the world that corrupts his thoughts about relations with other human beings. He said of himself that he had concerned himself more with studies than with men, and in these solitary, almost transcendental, meditations his prose is at its most free, rich and energetic. This is baroque prose, much closer to the language of Thomas Browne and Robert Burton, of John Aubrey, Jeremy Taylor and the Authorised Version, than it is to the plain expository style which the Royal Society, inspired by Bacon's *New Atlantis*, sought to make the vehicle of scientific thought.

Figures and conceits abound in these essays, resonant, mysterious, sometimes sinister. 'Truth may perhaps come to the price of a pearl, that sheweth best by day; but it will not rise to the price of a diamond or carbuncle, that sheweth best in varied lights.' 'Groans and convulsions, and a discoloured face, and friends weeping, and blacks, and obsequies, and the like, shew death terrible.' 'And at first let him practise with helps, as swimmers do with bladders or rushes; but after a time let him practise with disadvantages, as dancers do with thick shoes.' 'For the helmet of Pluto, which maketh the politic man go invisible, is secrecy in the counsel and celerity in the execution. For when things are once come to the execution, there is no secrecy comparable to celerity; like the motion of a bullet in the air, which flieth so swift as it outruns the eye.'

In a well-known essay on Bacon and the 'dissociation of sensibility' L. C. Knights has argued that the pervasively rich imagery of Bacon's prose is externally applied ornament, deliberately put on for illustrative purposes and not part of the actual fabric of his thought. He goes on to connect this with the new attitude to nature proclaimed in Bacon's writing, one in which nature is seen as a field of uses and manipulations, something alienated from the self, to be mastered, tricked, 'put to the

question'. Certainly Bacon's view of nature would make such a stylistic consequence plausible. One may agree that there is not the same delight in the visible world in a Baconian view of it as in the attitude of the pagan Renaissance. But in the middle ages nature was from an orthodox point of view a snare, appropriately mentioned in the same breath as the flesh and the devil. It could well be that the dissociation of sensibility is rather to be attributed to the way in which people lived, to the change from a comparatively natural to a comparatively artificial environment, than to any formal doctrines about the character of the natural world.

The kind of specialised pursuit of inductive natural science with a view to its technological application that Bacon heralded has come to be culturally estranged from art and the imagination. Bacon himself, indeed, while allocating a dignified place to the imagination in the life of the mind as the basis of 'poesy', acknowledged that 'imagination hardly produces sciences' and that poesy is 'rather a pleasure or play of wit than a science'. In the same spirit is his mechanisation of scientific inquiry and the associated principle that no special gifts are needed to make profitable use of his method in that inquiry. Bacon, then, honoured art and the imagination but was emphatic about the difference between art and science.

In his own brief but significant remarks on beauty, above all in his one-page essay on the subject, Bacon adopts a more or less romantic view of the essential creativeness of the artist. Against the idea of there being canons of art he says, 'a painter may make a better face than ever was; but he must do it by a kind of felicity, ... and not by rule' (E 788). The same attitude is expressed in his best-known aesthetic observation: 'there is no excellent beauty that hath not some strangeness in the proportions' (ibid). These explicit remarks and the high position he accorded poesy and the imagination led such apparently un-Baconian figures as Shelley to admire him. The richness and colour of his own prose is, indeed, less in harmony with his main message about natural knowledge and the relief of man's estate than the plain style deliberately adopted by the members of the Royal Society in pursuit of his intellectual ends.

9 Followers and critics

It is a commonplace about Bacon that he was remarkably blind to the important scientific work that was going on in his own time. To start with things near at hand, he ignored the brilliant work of his own doctor, William Harvey, on the circulation of the blood. By interpreting the crucial aspect of human vitality in hydraulic terms as a pumping system, Harvey prepared the way for another of Bacon's associates, Thomas Hobbes, to develop an account of man as a wholly natural object. Bacon dismissed another instance of major scientific advance in his own immediate environment, Gilbert's theory of magnetism, as a kind of occultist fantasy. Going further afield, he disdained Copernicus and ignored Kepler and Galileo.

Nevertheless there is no question about the degree of respect in which he was held by British scientists of the succeeding generation. Robert Hooke and Robert Boyle praised him without qualification and he became the patron saint or presiding deity of the Royal Society. Hobbes, the great scientific philosopher of the period after Bacon's death, took an absolutely opposed view of the nature of science and made no acknowledgement of Bacon. But he was no scientist, only an incautious amateur mathematician, and an object of scorn to the Baconians of the Royal Society. On the other hand, the grand culmination of British science in the seventeenth century, the work of Newton, contains the puzzling, but highly Baconian, phrase *hypotheses non fingo*.

In the eighteenth century the glorification of British science of the immediately preceding period, first by Voltaire and, following him, by all the great figures of the French Enlightenment, unhesitatingly included Bacon, seen as the great originator of the whole process. The more specific detail of Bacon's work as a classifier of the sciences was the most admired and authoritative exemplar for the work of the creators of the *Encyclopédie*, the great collaborative work in which the leading thinkers of the

French Enlightenment expressed their comprehensive liberal ideology in the light disguise of a reference book. Grateful praise is offered him in the *Discours préliminaire* by Jean d'Alembert, the great mathematician who was Diderot's co-editor.

The special regard of this particular party in the intellectual life of France explains two later, and directly opposed, attitudes to him. It is not surprising that Comte should have admired the most distinguished and unwavering prophet of positive science. On the other side, the most extreme and resonant of French conservatives, de Maistre, devoted a whole book of fierce criticism to Bacon and refers to him from time to time in more familiar works such as the *Soirées de Saint-Pétersbourg* as the initiator of the infidelity of the Enlightenment. For him Bacon is the first and most undisguised of those induced by satanic pride to reject the revealed knowledge judged by God to be sufficient for man and to turn from it to knowledge they have acquired on their own.

De Maistre's critique contains some knockabout philosophy of uncomplicatedly polemical intent. Bacon's belief that all causes are physical, he says, ignores the fact that laws of physical causation only describe. For explanation and real causes we must go behind nature to its transcendent source of motion. 'Full of an unconscious rancour, whose origin and nature he did not himself recognise, against all spiritual ideas, Bacon fastened the general attention with all his might upon the physical sciences in such a way as to turn men away from all other branches of learning ... In conformity with this system of philosophy, Bacon urges men to seek the cause of natural phenomena in the configuration of constituent atoms or molecules, the most false and gross idea ever to have stained the human understanding.'

If Bacon no longer elicits that sort of hostility, he does not excite the kind of enthusiasm among philosophers that he did from Comte and other nineteenth-century positivists such as G. H. Lewes, in whose *Biographical History of Philosophy* he occupies a position of honour. John Stuart Mill, indeed, pays Bacon the sincerest of compliments, that of rather exact imi-

tation, encumbered with some muddle-headed complications. But he makes hardly any reference to him in the *System of Logic*. Macaulay admired the prophet of utility and progress, despised the man and cast some inept aspersions on the inductive logician. (Macaulay objects that the inductive procedure Bacon systematises is natural to men and does not need to be formulated. That is an irrelevant objection to start with. It may be 'natural' to reason in a certain way as a matter of habit or custom. It is quite another thing to give explicit verbal expression to the rules embedded in that practice. It is also a false objection. Many thinking men no doubt reasoned in an eliminatively inductive way before Bacon came on the scene. It is still a somewhat exceptional and sophisticated style of inductive thinking. Simple enumeration, the logical equivalent of the formation of conditioned reflexes, is vastly more usual).

The Scottish philosophers of common sense of the late eighteenth and early nineteenth centuries, exponents of the official academic philosophy of Britain and America until the 1850s and 60s, were the last professionals to be really devoted admirers of Bacon as a philosopher, apart from a couple of rather obscure figures swimming against the prevailing idealist tide of late Victorian Oxford: Thomas Fowler and Thomas Case. The greatest of the pragmatists, C. S. Peirce, wrote that 'superior as Lord Bacon's conception is to earlier notions, a modern reader who is not in awe of his grandiloquence is chiefly struck by the inadequacy of his view of scientific procedure'. He goes on to argue that any mechanical system, such as Bacon's tables of exclusion, cannot produce significant scientific knowledge.

Bacon has been almost wholly neglected by the analytic philosophers of the twentieth century. Von Wright, as we have seen, tried to do him justice in some brief historical asides in his writings on induction. But the major figures – Russell, Moore, Wittgenstein and Carnap – have next to nothing to say about him. This is partly because the treatment of induction by analytic philosophers has concentrated on the conception of it as *probable inference*, and the notion of probability has no place in Bacon's thinking, convinced as he was that his method was capable of yielding certain knowledge of the laws of nature.

More generally, in their eyes Bacon lacks the right sort of rigour. Where his exposition is reasonably exact, as in his theory of elimination, it is the philosophically uncontroversial aspect of the field with which it is concerned and, where noticed at all, it is remitted to textbooks. But for the most part the admixture of rhetoric with argument is too strong for currently austere philosophical tastes.

The one important exception to this is the attention given to Bacon by Sir Karl Popper in his influential books on the philosophy of science. Popper sees the imaginative speculation, condemned by Bacon as the intellectual vice of scholasticism, as the nerve of scientific progress. Bacon's idea of scientific theorising as a mechanisable business, owing nothing to the special gifts of those who pursue it, is something it has been his main task to repudiate. It is interesting that he uses to undermine Bacon's position the very logical feature of general statements, the greater force of the negative instance, which Bacon relied on to demonstrate the weakness of simple enumeration. Popper would claim that by developing the full potential of the idea he has shown how little Bacon succeeded in making of it. Nevertheless he counts Bacon as an ally on the very broadest front, in opposition to the kind of purely verbal speculation which never puts its findings to the test of experience, recognising Bacon as a fellow-rationalist in the good, nineteenth-century sense of that word. On a particular point he suggests persuasively that there is less difference between what Bacon understood by true induction and what Aristotle did, the procedure now labelled 'intuitive induction' (cf. p. 57 above), than is usually supposed. Bacon himself thought that Aristotelian induction was simply enumerative, so he was in no position to acknowledge the identity of view, even if Popper is right about what he means by 'the interpretation of nature'.

Popper's, and for that matter Peirce's, criticisms are only particularly thorough and sophisticated versions of one of the two main and persistent objections to Bacon's theory of science, that it wholly fails to accord an adequate place to hypothesis, the imaginative construction of novel theories. As a result he neglected the importance of scientific creativity and, in his

ideas about the levelling of men's wits, of the very marked inequality with which it is distributed. The other leading objection is that, unlike the Italian philosophers of nature who preceded him, he failed altogether to understand the importance of mathematics for the natural science of the new age.

This second deficiency – and it is, of course a real one – stemmed largely from the fact that he did not know much about mathematics anyway. But there is a more philosophical, or at any rate ideological, factor involved, namely the close association between mathematics and occultism, shown in numerology, astrology, the measuring of pyramids and the calculating of millennia. An analogous factor was at work in his attitude to imaginative speculation, namely his identification of it with the cobweb-spinning verbalism of the more dismally repetitive kind of academic Aristotelian.

A third weakness which is large enough to be mentioned alongside the two just considered is his dogmatism, his failure to conceive that the price of substantial general beliefs is uncertainty, that we cannot do more than confirm, render more or less rationally credible, the theories about the world in which science consists. It is not an objection of principle, but it is still an objection, that he made such an insensitive response to the real scientific advances of his own age.

He is sometimes defended on grounds of being too early on the scene, since, it is said, his methods, although not those of the great physicists of the seventeenth century, were very much those of the biologists of the nineteenth, as the greatest of them, Charles Darwin, explicitly testifies. If that is so, the same could be said of his ideas about the connection between science and technology. Science contributed negligibly to economic production before the nineteenth century and the emergence of industrially applicable chemistry. What it did do was help in the production of more science by making possible new scientific instruments.

Bacon's main claim to importance must rest on his role as a prophet and a critic. It remains a very large claim. His firm separation of science from religion and religious metaphysics; his transformation of the status of natural investigation from

that of the forbidden, when seen as sorcery, or the despised, when seen as low drudgery; his intoxicating programme of a vast increase in human power and pleasure through inquiry in a great array of clearly and colourfully delineated fields – all these add up to a major turning-point in the history of the European mind. For it is the empirical natural science which Bacon called for and the technology that eventually sprang from it that have been the main contribution, an incalculably great and irrevocably ambiguous one, that Europe has made to the world, first by political mastery, now, more subtly, by mastery of thought. The completeness of his vision of a human future dominated by natural science was a speculative and wholly non-inductive leap of the mind which is none the less admirable for its uneasy conformity with his own ideas about the growth of knowledge.

Note on sources

The references for quotations from authors other than Bacon are as follows:

Page

4 John Aubrey, *Brief Lives*, edited by Anthony Powell, London, 1949, p. 190

7–8 ibid., pp. 192–3

11 Thomas Hobbes, *English Works*, ed. W. Molesworth, London, 1839, p. 360

31–2 K. R. Popper, *The Open Society aud its Enemies*, Princeton, 1950, p. 203

33 J. H. Randall Jr, *The Career of Philosophy*, New York, 1962, vol. 1, p. 228

33 Friedrich Heer, *The Intellectual History of Europe*, New York, 1968, vol 2, p. 150

56 G. H. Von Wright, *Treatise on Probability and Induction*, London, 1951, p. 152

63 W. C. Kneale, *Probability and Induction*, Oxford, 1949, p. 51

63 W. R. Sorley, *History of English Philosophy*, Cambridge, 1920, p. 27

72 C. D. Broad, *Ethics and the History of Philosophy*, London, 1952, p. 124

72 W. Holdsworth, *History of English Law*, London, 1924, vol. 5, p. 239

72 id., *Some Makers of English Law*, Cambridge, 1938, p. 108

73 H. R. Trevor-Roper, *Religion, Reformation and Social Change*, London, 1967, p. 84

75 Douglas Bush, *The Earlier Seventeenth Century*, Oxford, 1946, p. 186

77 L. C. Knights, *Explorations*, London, 1946

80 J. Lively (ed.), *The Works of Joseph de Maistre*, New York, 1965, pp. 228–9

80 J. Buchler (ed.), *The Philosophy of Peirce*, London, 1940,
 p. 5

82 K. R. Popper, *Conjectures and Refutations*, London, 1963,
 pp. 12–15

Further reading

The authoritative edition of Bacon's writings is the *Works* in 7
volumes, edited by James Spedding, R. L. Ellis and D. D.
Heath (London, 1857–74). For all but the most refined pur-
poses *Philosophical Works*, edited by J. M. Robertson (London,
1905) is entirely sufficient, being a one-volume selection of all
the important items from the Spedding–Ellis–Heath compila-
tion, together with W. Rawley's brief life of Bacon. Easier to
get hold of is *Selected Writings of Francis Bacon*, edited for
the Modern Library by Hugh C. Dick (New York, 1955). The
Essays and *Advancement of Learning* are both available in
Everyman's Library and World's Classics editions. For further
detail see R. W. Gibson, *Bacon: A Bibliography of His Works
and of Baconiana to the Year 1750* (Oxford, 1950).

The main biography of Bacon is *The Life and Letters of
Bacon*, published in seven volumes between 1861 and 1874 by
his editor, James Spedding. Much more manageable and very
little damaged by the passage of time is the biography by R. W.
Church: *Bacon* (London, 1884). Another nineteenth-century
biography on a reasonable scale is the first and better of the
two volumes of J. Nichol's *Bacon* (London and Edinburgh,
1888–9). Macaulay's lively piece can be found in any edition of
Macaulay's literary essays (it was originally published in 1837).

One of the best books wholly devoted to Bacon's philosophy
is nearly a century old: Thomas Fowler's brief, clear and sen-
sible *Bacon* (London, 1881). There is a very good article by
Robert Adamson in the 11th edition of the *Encyclopaedia
Britannica* (Cambridge, 1911). The only substantial modern
book wholly concerned with Bacon as a philosopher is F. H.
Anderson's *The Philosophy of Francis Bacon* (Chicago, 1948).
This is a largely uncritical and unhistorical exposition and

ordering of Bacon's views on the errors of his predecessors and the right method for the investigation of nature. A materialist line is taken about Bacon's emphatic separation of science and religion. Paolo Rossi's *Francis Bacon: From Magic to Science* (London, 1968) is more a usefully learned piece of intellectual history than a work of philosophy strictly so called.

There are good comprehensive essays on Bacon's philosophy by two well-known twentieth-century philosophers: one by A. E. Taylor in his *Philosophical Studies* (London, 1934), the other by C. D. Broad in his *Ethics and the History of Philosophy* (London, 1952). A more recent brief general account that can be recommended is the chapter on Bacon contributed by Mary Hesse to *A Critical History of Western Philosophy*, edited by D. J. O'Connor (London, 1964).

The most important essay on a crucial aspect of Bacon's philosophy is Tadeusz Kotarbiński's 'Development of the Main Problem in the Philosophy of Francis Bacon' in *Studia Philosophica I* (Lwow, 1935), where there are also abstracts of two other articles by him on Bacon. There are good treatments of Bacon's ideas about induction in chapter 12 of William Kneale's *Probability and Induction* (Oxford, 1948) and in chapter 4 of G. H. von Wright's *The Logical Problem of Induction* (2nd ed. (revised), Oxford, 1957).

A broad array of articles of largely extra-philosophical interest on Bacon has been edited by Brian Vickers: *Essential Articles for the Study of Francis Bacon* (Connecticut, 1968), in which the items by R. F. Jones and V. K. Whittaker are of particular interest.

The intellectual context of Bacon's philosophy can be studied in H. Höffding's *History of Modern Philosophy* (London, 1920) in books 1 and 2 of the first volume, or in book II of the first volume of *The Career of Philosophy* by J. H. Randall Jr (New York, 1962). See also Charles Webster's *The Great Instauration* (London, 1975).

Of interest about Bacon from a literary point of view are Lisa Jardine, *Francis Bacon: Discovery and the Art of Discourse* (Cambridge, 1974) and Brian Vickers, *Francis Bacon and Renaissance Prose* (Cambridge, 1968).

Index